DRAWING PORTRAITS

by Douglas R. Graves

WATSON-GUPTILL PUBLICATIONS, New York

Paperback Edition
First Printing 1983

Copyright © 1974 by Watson-Guptill Publications

First published in 1974 in the United States and Canada by
Watson-Guptill Publications, a division of VNU Business Media, Inc.
770 Broadway, New York, NY 10003
www.wgpub.com

Library of Congress Catalog Card Number: 74-9718
ISBN 0-8230-1430-4
ISBN 0-8230-1431-2 pbk.

Manufactured in U.S.A.

19 20 21/08 07 06 05

To Mom and Fran

Contents

Acknowledgments

An author and illustrator needs all kinds of people—to untangle his thoughts, to encourage him, to prod him to further work, to design something beautiful from his disaster, to care for him, and of course, to buy his books. Such people are: Claire Hardiman, Diane Hines, Donald Holden, Jim Craig, all at Watson-Guptill; my wife Bea; Vernon Stake, and many other friends.

Introduction

If this is to be a course in portrait drawing, then the prerequisites are that you've done some drawing from life and developed good hand and eye coordination. Otherwise, the hints on figure construction given here will be nothing more than theory. You have to be able to interpret and utilize the information if it is to be at all useful to you.

In this book, I'll discuss the art and craft of portraiture from beginning to end—seeing and drawing the anatomy of the head and hands, posing and lighting the sitter, conveying the weight, texture, and drape of the sitter's clothing, composing the portrait (individual as well as group), and dealing with such auxiliary problems as the relationship between the artist and his sitter.

Once you understand all the rudiments of structure, you're free to develop your own style as far as the way you work and the materials you use. Some drawings can be very painterly, done with pastels; others can be vigorous linear sketches such as those by René Bouché or Paul Hogarth. I mention the work of these artists because to me they are ultimate examples of portrait drawing. There's no fumbling, unnecessary shading, or scratching around in their work. I can't tell you exactly *how* this is done; however, after a great deal of practice, you'll probably find the few lines that say what you want to say.

If I could label what I do, I'd say I'm a cross between a dauber and a nervous scratcher. My eye is pretty good and I always hope fervently that it saves the drawing. Remember—don't give up—you'll probably have to do many portrait drawings before you find your own personal style.

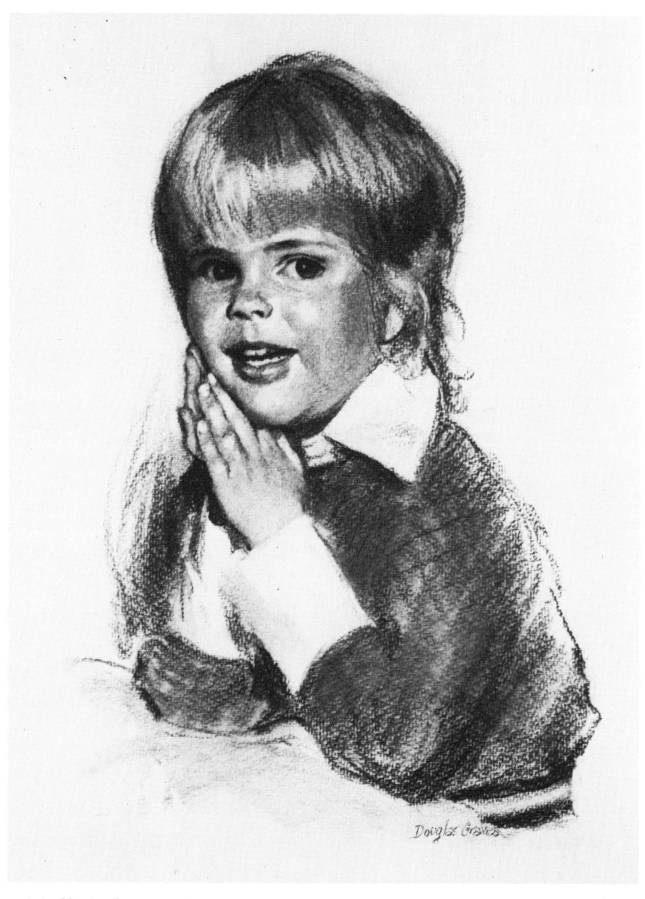

Katie (Kathleen) Beck. *11" x 14". Charcoal on D'Arches Ingres paper. Collection of Mr. and Mrs. Robert Keegan.*

MATERIALS
AND
TECHNIQUES

1.
Materials

Figure 1. *Random strokes with soft vine charcoal on Canson Ingres "laid" charcoal paper.*

There's a tremendous variety of interesting materials you can use to draw portraits. The three basic kinds of media we're going to play around with are: charcoal, pencil, and chalk. With these, you can run the gamut from soft, smudgy drawings, to crisp, linear pencil sketches, to colorful chalk drawings that are almost paintings.

Vine Charcoal On Charcoal Paper

Vine charcoal is the easiest medium for drawing. It can be pushed around, easily changed, or erased. You have available a full tonal range from pitch blacks, to delicate grays, to white. The kneaded eraser, chamois, a bristle brush—even your finger—can be used to get lighter tones and whites. There is paper manufactured especially for vine charcoal, though pastel paper and even watercolor papers can also be used. The conventional charcoal papers, such as those made by Strathmore or Canson are rag-content papers that have "tooth," or texture. This holds the charcoal to the paper and gives interesting textural effects. Charcoal papers are also treated chemically with gelatin to make the charcoal adhere to the surface. (See Figures 1–6 for different techniques with vine charcoal.)

Compressed Charcoal on Clay-Coated Papers

Compressed charcoal is made by grinding and compressing charcoal with clay or chalk—some-

Figure 4. *Again, the same series of tones as in Figures 2 and 3, this time blended thoroughly with an oil bristle brush.*

Figure 2. *A progressive series of hatching strokes to achieve a curving form. No rubbing or blending here. The lighter tones are done with a harder vine charcoal, the darker ones with a soft stick.*

Figure 3. *Here the same series of tones as in Figure 2 are blended with a foam-rubber pad. Notice that the strokes angle across the laid texture of the paper. This is a natural direction of working for a right-handed person. It also makes an interesting texture combination.*

Figure 5. *This shows how vine charcoal can be erased or lifted out for the "lights" with a kneaded eraser or a Pink Pearl eraser.*

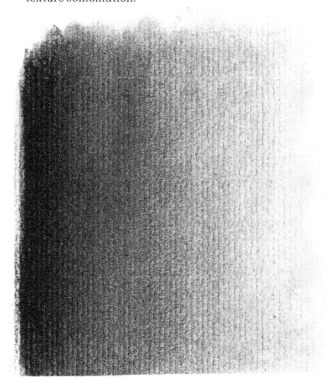

Figure 6. *This shading is done in the same direction as the laid texture of the paper and blended completely. Notice that less texture is evident here than in the preceding illustrations, in which the strokes angle across the laid texture.*

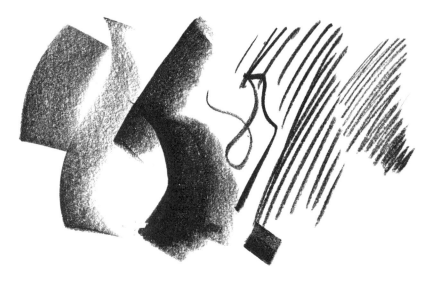

Figure 7. These are different kinds of strokes done with compressed charcoal on a plate paper. The blacks are rich looking, the texture is minimal, and the edges are fairly sharp.

Figure 8. A stroke of heavy, compressed charcoal on a plate paper rubbed with a finger to get a graduated tonal swatch.

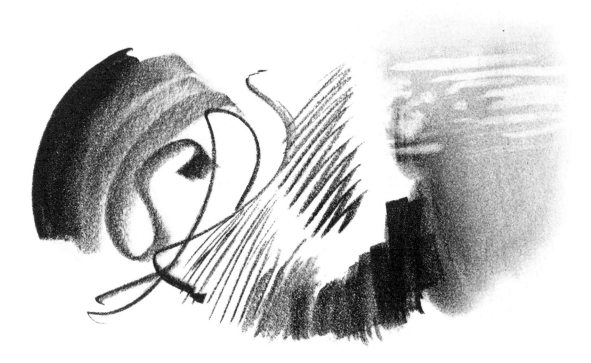

Figure 10. Compressed charcoal on layout bond is pleasing, giving a fair amount of texture and blending nicely.

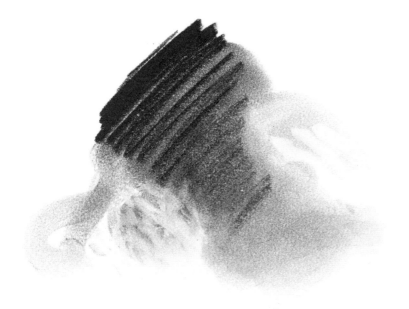

Figure 9. *The same paper and charcoal as in Figure 7 but I rub my finger over the zigzag shading to blend it. The eraser can lift out spots, and also, as in bottom center, make a texture almost like that of oil painting.*

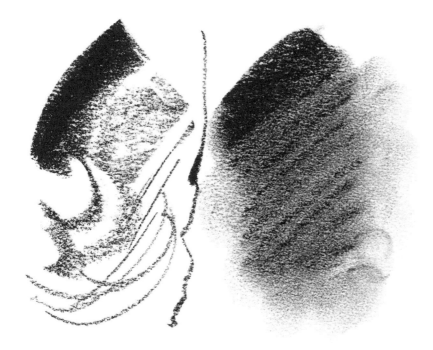

Figure 11. *If you like more grain to the work, cold-pressed illustration board is an interesting surface to use with compressed charcoal. A line drawing holds up pretty well, too.*

times even tapioca. The charcoal is dense black, on the verge of being greasy. Since compressed charcoal is softer than vine charcoal, it doesn't work well on a textured paper. Why? It gums up and doesn't blend nicely like it does on a smoother surface. Papers or boards that are clay-coated—such as illustration board, plate card, or a heavy bond paper—seem to work better. On these surfaces, compressed charcoal makes a rich, warm black. You can blend smooth tones with your fingers. If you're going in for something on a grand scale, such as a charcoal portrait on gesso-coated Masonite, then by all means use the compressed charcoal (see Figures 7-11.)

Graphite Pencil

Pencils, such as graphite, are relatives of the traditional silver and gold points. Graphite pencils in the harder grades have a silvery sheen that's as subtle as the silver point, yet, the softer grades can be as strong and dark as charcoal. Most beginners in portrait drawing, or any other kind of drawing, pick up the graphite pencil. It seems comfortable because it's been your most constant childhood companion for writing, doodling, and drawing. There's no question about the ease of control and the natural way we all take to pencil—but here's where I always get into trouble with students: it's strictly a professional's instrument.

Graphite pencil is difficult because it's a "direct" medium. That is, you must apply it *exactly right* the first time, while with other media, such as charcoal, you get a second or third chance. Erasing can't be done without spoiling the texture and inherent beauty of pencil, since unlike charcoal, it smudges badly and never completely lifts out. Graphite actually is a lubricant, so attempting to erase it makes the eraser slip over it, leaving an ugly smear. The softer grades of pencil will also stain paper. Remember, when you want to pencil in preliminary guidelines, use a very hard grade

pencil, so it won't stain and will erase easier. A pencil portrait will only look professional if it's done with strength and sureness and in a direct manner. Figures 12–22 show some examples of the types of techniques and surfaces for graphite pencil drawing. Notice that definite strokes (both open and closed) are used to shade with pencil as opposed to the smudging technique used with charcoal and chalk.

Two other types of pencils that will interest you are the white charcoal (how charcoal can be white is a puzzle!) and black carbon pencils. A white pencil used alone on a gray or brown pastel paper makes a striking drawing, with the paper lending its own tone to the drawing. If you use paper that has a light middle-tone, and you play the black pencil against the white, the combination can be very effective. Figure 29 shows the textures and tones of these pencils.

Conté and Chalk

Some clients aren't attuned to full-color paintings and prefer monochromatic art. Conté drawings impart a feeling of color without getting into the problems of color. There's a wide range of possible techniques and grounds to work on. Conté is a powdered pigment compressed into sticks of different colors: bistre, sanguine, black, and white. Pastel chalks or crayons, of course, come in a wide range of color. The most pleasing of these for flesh tones are warm sepias and browns, though I suppose dark green or blue could be used for adding a different mood to a portrait.

Conté is water-soluble but pastel is not. By using a brush and water carefully, you can produce a picture somewhere between a drawing and a painting. This kind of a rendering can be very exciting but requires a great deal of restraint and practice. The Conté "catches fire" (not literally) and you'll have a big red smear in a hurry, so work lightly and quickly.

Figure 12. *An 8H graphite pencil makes a sharp silvery line. No amount of heavy shading becomes very black. It erases easily, making it a good grade for preliminary sketching that has to be erased clean. These and the following swatches of graphite are on cold-pressed illustration board.*

Figure 13. *The 5H graphite is still silvery and sharp but a shade darker than the 8H.*

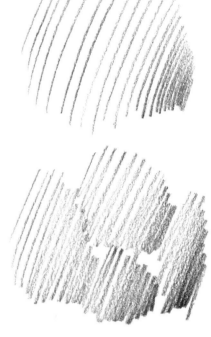

Figure 14. *The H graphite isn't as hard as you'd think it would be. It can be a good general-purpose sketching tool, but it's still not black. The grades from here on are difficult, even impossible, to erase without smearing.*

Figure 18. *5B graphite pencil.*

Figure 19. *This example is done with a pencil I like, a Mars Lumograph, Ex-ExB grade. It's really black—looks almost like charcoal but still has a graphite feel.*

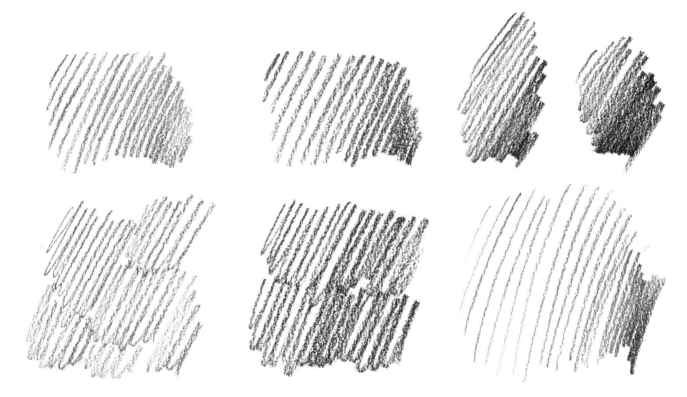

Figure 15. *These swatches, through Figure 18, are progressively darker graphites, HB, 2B, 4B and 5B. They become slightly grainy and lines aren't as clean. This is the HB graphite pencil.*

Figure 16. *2B graphite pencil.*

Figure 17. *4B graphite pencil.*

Figure 20. *Here are the 7 grades of graphite used in a hatching manner to get around a form. This is one of the "cleanest" ways to use graphite pencils.*

Figure 21. *You can close up the strokes and make them directional but less formal. On the left, the strokes are more open while on the right they are closed as much as possible without getting too smudgy looking. Start with the softest pencils and work the hard grades into them for a smoother blend.*

Figure 22. *A sharp-pointed HB graphite makes a clean, expressive line.*

Other techniques which can be used with Conté are hatching, rubbing with the fingers or paper stomps, drawing with broad side-swipes or just using a pure clean line. Figures 30–39 show the different textures possible with both Conté and chalk.

The effects of Conté and chalk will depend on the surface you use. For paper, I'd suggest either a pastel paper or a calendered paper like a layout bond, but not a charcoal paper. A gesso surface (both the old-fashioned glue gesso and the acrylic) makes a fascinating ground for your drawing since how you apply the gesso on the support will influence the drawing. For example, if you stroke the gesso on thickly with a brush, you'll get a textured surface similar to those shown in Figures 36 and 37. Masonite (the untempered variety) is firstrate for use with gesso. You should also consider the weight and strength of the paper, if the work is to be very large. A heavy chipboard or wallboard would be a good substitute in that case.

Fixative

This subject is debatable. As far as vine charcoal drawings are concerned, I personally do not like to

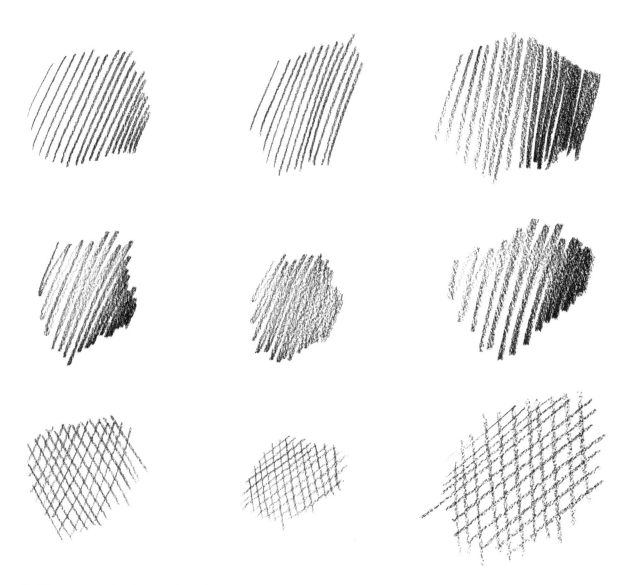

Figure 23. *These are strokes done with a Wolff's H grade carbon pencil on cold-pressed illustration board. The lines are dark and clean.*

Figure 24. *The Wolff's HB is somewhat fuzzier, and unless you press hard it isn't much darker than the H.*

Figure 25. *A grade B carbon pencil on illustration board.*

fix them at all. Soft-charcoal drawings are insulted by fixative; they die a little. If you accidentally get too close with the spray can, the air pressure will literally blow some of the particles off the paper or onto surrounding tones. The rich blacks you've so carefully laid on are no longer as rich; the whites you've so tediously lifted out with the eraser are filled in with charcoal dust forever. In or-der to really get it fixed well, you have to spray and spray, and then the drawing takes on a gray pallor. If you spray too much on too soon, the drawing will just dissolve.

So to avoid these problems, I frame my charcoal drawings my-self, without fixative or with only very light applications. I mat the drawing with two thicknesses so the glass and drawing don't touch each other. Then I seal the back in tight and pray that no one will ever open it up again. Pastels and Conté *can* be fixed with only a slight discoloration and you don't have to worry about disturbing the relationship of several colors in a monochromatic work. Pencil can and should be fixed, so use a non-yellowing type and fix it well; the tones won't change a bit.

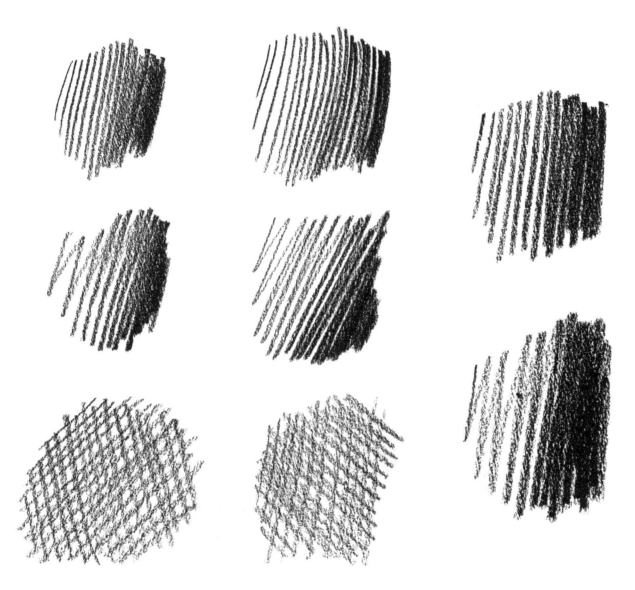

Figure 26. *A grade BB carbon pencil.*

Figure 27. *A grade BBB carbon pencil. If the pencil isn't well sharpened the lines will lose their crispness the darker they get. However, carbon pencils tend to break when you try to hone them to a point. These grades are better for the wider, darker strokes. For a sharp line it would be best to use grades H or HB.*

Figure 28. *It's possible that Wolff's has a softer grade than BBB, but if you can't find any, the General's brand comes in a 6B. It's really black. None of these grades of carbon and char-coal pencils can be erased success-fully. For that reason this medium is even more difficult to use than graph-ite.*

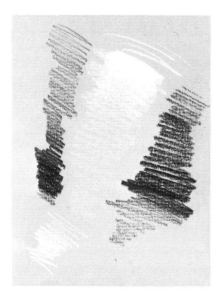

Figure 29. *The combination of the white and black charcoal pencils on a toned pastel paper is a fun way to work. The results are quick because the paper bridges the gap of tones between the extreme black and white.*

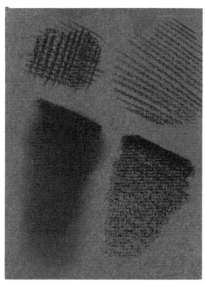

Figure 30. *These are different strokes of black in a soft, round stick done on a dark blue pastel paper. The combination lends itself better to a tonal mass approach than to a linear technique.*

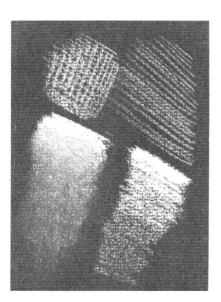

Figure 31. *Soft pastel stick in white on a dark-toned paper.*

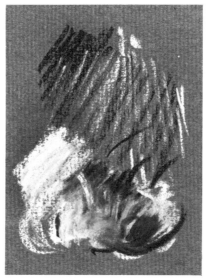

Figure 32. *The pairing of black and white soft pastels on toned paper gives a sparkling quality to the drawing, and effects are quickly achieved. The pastel chalks can be fused, and worked on top of or into one another to become almost like oil paint.*

Checklist of Supplies

The inventory of drawing materials will be very easy on your bank account compared to painting. Here's a list of what you'll need:

1. Vine charcoal, round or square
2. Compressed charcoal
3. Chamois
4. Kneaded eraser
5. Bristle brush (filbert oil brush No. 6)
6. Pink pearl eraser
7. Charcoal paper (Strathmore, Canson Ingres)
8. Conté crayons and your choice of pastel colors (use square, hard sticks on gesso panels, and soft, round sticks on paper)
9. Bristle brush for Conté
10. Pastel paper (gray, brown or blue)
11. Paper, bond or plate
12. Masonite coated with gesso
13. Graphite pencils, grades 8H, 5H, H, 2B, 4B, 5B, Venus and Mars Lumograph
14. Black and white charcoal and carbon pencils (Black Wolff, grades H, B, BB, BBB and General 6B)
15. Illustration board, cold pressed or hot pressed
16. Fixative

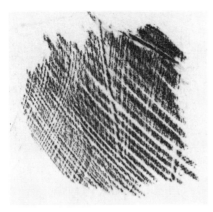

Figure 33. *A hard, square stick of pastel stroked on a surface that has been coated with acrylic gesso. If the gesso has been applied thickly or in several coats, the strokes of chalk will bring this out.*

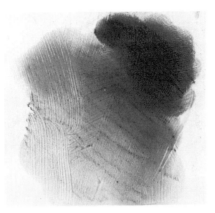

Figure 34. *Hard pastel chalk on the same surface but rubbed with a finger. The texture of the gesso is not so apparent in this application.*

Figure 35. *A kneaded eraser can lift the rubbed pastel off the acrylic surface.*

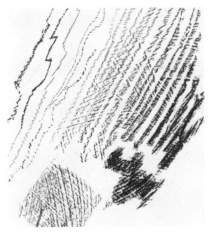

Figure 36 *Conté used on a gessoed illustration board behaves much the same as pastel because, in a way, they're both chalks. Use either a linear or a tonal mass technique.*

Figure 37. *If the Conté is rubbed with a finger or stomp, it makes an intense tone. The brushstrokes of the ground don't show up as much.*

Figure 38. *After acrylic gesso has been applied to a support, such as illustration board, chipboard, or Masonite, the brushmarks may not be to your liking. Sanding each coat you apply will eliminate some or all of the brushmarks, allowing the texture of the Conté itself to become dominant.*

Figure 39. *Brushing water on the Conté dissolves it into washy tones. Drawing back into the wash produces fuzzy lines. Any Conté that has been dissolved with water needn't be fixed. (A purist may not consider this a valid drawing technique!)*

2. Head Structure

Before doing any portraits, I think it's important that you review some of the underlying anatomical essentials of the correctly drawn head. In the beginning, you may believe that your portraiture difficulties are due to something ethereal and mysterious, but it's usually some simple, basic problem like losing the roundness of the head, or having the eyes lined up improperly. After you really get into portraiture, drawing these details will come easily to you. See Figure 40 for a sketch of the basic bone structure of the head.

Seeking the perfect solution to the problem of head-structure proportions has been the goal of figure artists, painters, and instructors for ages. Usually I rely on vision to determine proportions, but you'll probably find that some actual measurements are helpful as a foundation or as a check on your visual acuity. To begin with I see the head as an oval. Actually, the head is a more complex shape—one that's hard to comprehend at first—but I haven't found a simpler or better way to visualize the head than as an oval. Later, you can progress to the head's more intricate configurations; if you get the head's larger aspects right, then those smaller features are more apt to be coherent.

Following that principle, the sketches and diagrams in this chapter will deal first with the whole head and the division of it for placement of components, and second, with the detailed structure of the individual features.

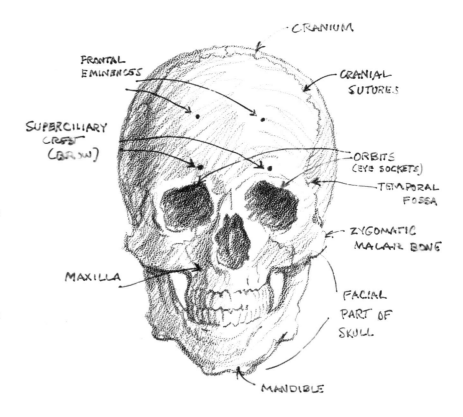

Figure 40. *A rough sketch of the skull will serve as a reference for my remarks on the anatomical structure of the head.*

Proportions for the Head in Profile

In Figure 41, I begin to draw the head in profile, dividing an oval shape in half lengthwise, and then marking off four equal divisions from top to bottom. In the lower left, I make two of these divisions a square and this becomes the facial part of the skull. Notice that the upper left corner of the square is the farthest point forward on the oval, and marks off the base of the nose. In the third step, you can also see that the top side of the square demarcates the eyeline; I place the eye back into the oval about one-quarter of the side of the square. I draw the nose equal to one of the lengthwise head divisions. To indicate the plane of the cheek, I sketch a line slanting from the base of the nose back up to the eye socket. I estimate the jawline at the second of the four divisions across the bottom of the square. I place the ears approximately between the eyebrows and the bottom of the nose. The complete head can be easily visualized by the fourth step. The brow slants back, following the oval slightly. The lipline is located halfway between the base of the nose and the chin. The topmost division of the head gives you an idea of where the hairline will be. Of course, this varies according to hairstyles and individual facial structure, so that the hairline can be drawn any place. Remember that since the hair can be of any thickness, you shouldn't consider it in any measurements of the skull. In general, when drawing hair, just follow through with the head oval. Notice that here, as in the front view, the cranium rises noticeably back to the crown.

In the last steps you can see that a woman's head is basically the same size as a man's, but a few alterations are necessary. For example, her brow is flatter than the man's, with no overhang. Also, the lower part of the woman's face is more petite, so you can shorten the divisions somewhat. Compare the difference in length of the three divisions from the nose to the chin in the man's and woman's profile.

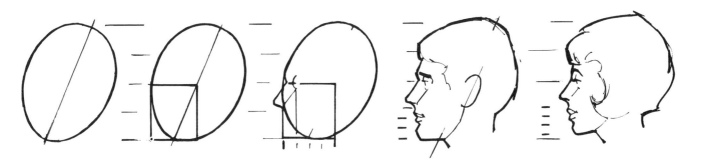

Figure 41. *In the first three diagrams (left to right) you see the main divisions of the head in profile for both male and female.*

Proportions for the Front View of the Head

In the first step for the front view of the head (Figure 42), I again divide the oval in half lengthwise, and mark off four divisions. Then I slice off the sides of the oval between the two middle divisions. I locate the pupils on the center horizontal line, halfway between each side slice and the center vertical line. In the second step, I place the eyebrows. Actually, they can be almost anyplace, but should remain fairly close to the eyeline. The nose is an "oil-derrick" shape extending along the third lengthwise division of the center line. As before, I draw the lipline halfway between the base of the nose and chin. In the next step you can see how the various facial features align. I divide the area between the eyes into three sections, each about half the area between the center vertical line and the side slice of the head. I drop lines from the inner corners of the eyes and to the outer points of the lower lips and the chin. Continuing these lines back up the sides of the face to the eye level gives you an approximate outline of the side facial planes. You can think of these lines as forming either two overlapping V's or a W. The eyebrows line up with the opposite upper eyelid line in a flat X shape. I drop plumb lines from the inner eye corners to locate the wings of the nose, and from the pupils to the outer corners of the mouth. I complete the faces of both the man and woman from these basic guidelines. Some slight differences between the man and woman are apparent here also, such as the higher arch of the woman's eyebrows, and her narrower mouth and chin area. The woman's nose is also smaller and more dainty. Keep in mind that these measurements are always just approximations and only worth considering as check points to confirm the correctness of your observations of heads. Every movement of the head swings all its components and measurements into a different perspective. However, since the head will be only in a limited number of positions in portraiture, you don't have to worry about strange and difficult head positions. For your own confidence in drawing a head, I'd suggest you study both from life and from some good books, such as Burne Hogarth's *Drawing the Human Head* (see Bibliography).

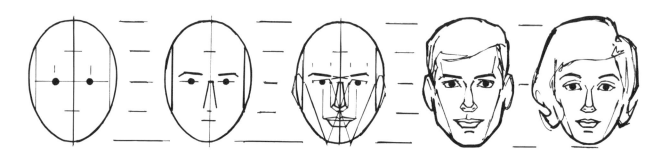

Figure 42. *In the first three diagrams shown here (left to right), you see the main divisions of the front view of the head for both male and female.*

Visualizing the Turning Head

These four sketches, and the diagrams below each one (Figure 43 A, B, C, D), demonstrate a slightly uptilted head as it turns. It is a common portrait position, flattering to most people. In either the front view or the profile position, an oval is fine for visualizing the head, but how do you analyze it when it moves away from those perfect poses? By overlapping two oval or egg shapes, you can visualize the way a head changes as it is seen in different positions. This time, imagine the lengthwise dividing line as a meridian fully encircling the head. In Diagram A, the two ovals are closely allied, but as the head rotates in Diagram B, one oval begins a sharp upward movement. The other oval starts to tilt out slightly, and by Diagram C, becomes stationary. The first oval continues its upward thrust until it reaches this position shown in Diagram D.

These sketches show the contrast between the basic shape of the cranium, which is somewhat rounded, and the facial area, which is more planar. Notice that the ear is positioned behind the side lengthwise division, and that it protrudes from the silhouette of the cranium, while the nose remains inside the facial boundary. As the head turns farther away, it pulls the ear within the skull boundary, and then the nose emerges from the silhouette. The rule is: one in, the other out!

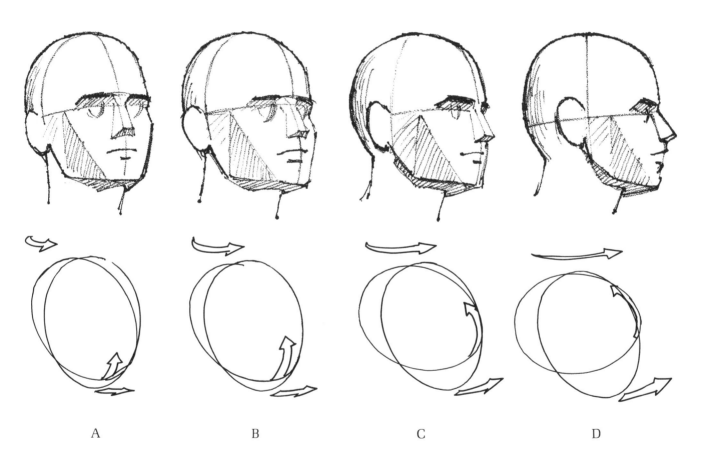

A B C D

Figure 43. *These four sketches give views of the male head as it turns away from the viewer into a full profile. Below each sketch is a diagrammatic shape composed of two overlapping ovals. These diagrams should help you visualize the positions of the head that fall between front and profile views.*

Planes of the Head

I use a man's head in Figure 44 to analyze some of the planes of the head. Although the skull is basically round, some evidence of planes is there. For instance, the sides of the head above the ears appear somewhat flattened. Also, there is a definite plane along the side of the forehead down to the eyebrow. Four subtle bulges, not planes, form the frontal and superciliary eminences. On a man, the area between the eyebrows sometimes creases and forms vertical planes. The eye sockets undercut the brow and merge with the side forehead planes. The group of muscles that draws the corner of the mouth and cheek upward form planes down the cheeks. If the cheeks are fleshy or if there's any hint of a smile, planes radiate out and down from the nose wings. These and the muscles around the mouth exhibit different shadow formations on each side because of the light raking from left to right. Furthermore, the planes of a human head, as with any flesh-and-bone entity, result from subtle changes in composition.

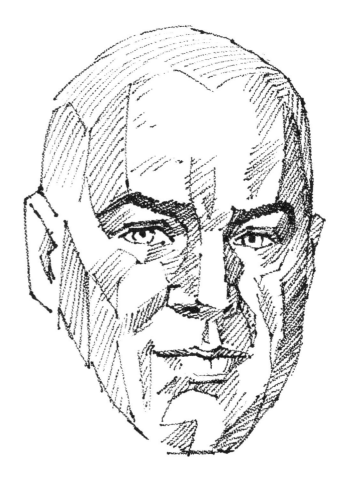

Figure 44. *In this sketch of a man's head I've emphasized the planes of the face with diagonal strokes.*

Skull Configurations

Figure 45 shows the contrast of skull configuration between the adult and the child. The most noticeable difference is the lack of development in the facial part of the child's skull until permanent teeth emerge. Although smaller than the adult's, the child's cranium (in relation to his facial bones), is the fastest growing part of the skull. Up until the age of seven or eight, the child's cranium has more of a circular shape than an oval. Because the face is the slowest in development, the child's eyeline is much lower than the adult's. Also, the child's neck is very thin and this makes the cranium seem to bulge out more in the profile view. Face on, the frontal and superciliary eminences are especially prominent because the features underneath haven't fully grown.

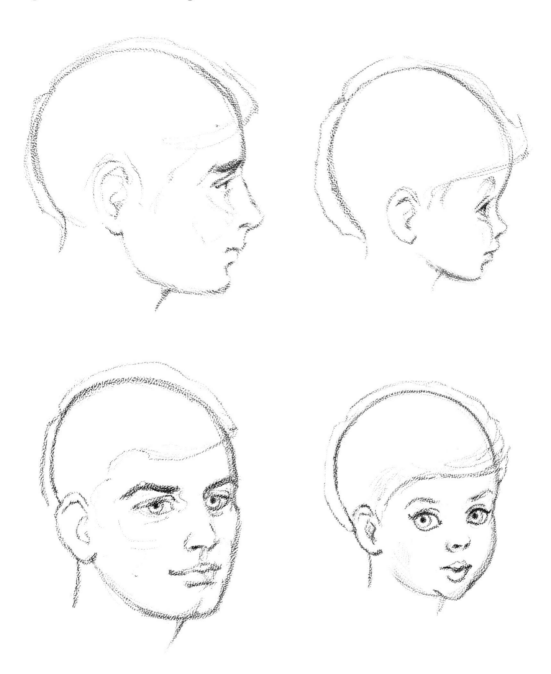

Figure 45. *Here you can see the difference in the skull configurations of an adult and a child. The two top sketches are in profile; the two bottom sketches are three-quarter views.*

Perspective and the Turning Head

I have already mentioned that the varying perspectives of the turning head will have an effect on all your alignments. When the head moves into the positions shown in Figure 43, the second (stationary) oval represents the facial area. So it follows that, in Figure 46, you have to envision those overlapping V's (demonstrated in Figure 42) so they follow the curvature of the face. The plumb lines from the eye corners also curve down to the nose wings. Don't forget the effect of perspective; the farther plumb lines should be closer to the center of the face.

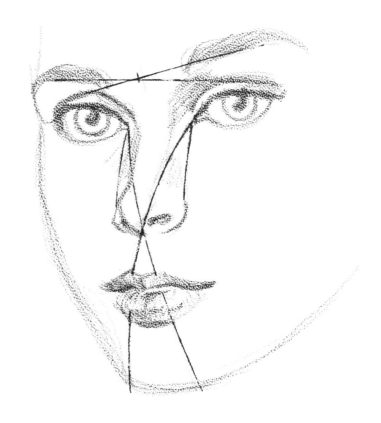

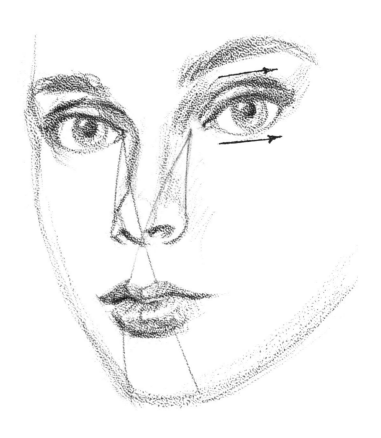

Figure 46. *(Above) In this diagram you can see the relationship of the features to the curve of the face—the second oval that you saw in Figure 43.*

Figure 47. *(Right) Look what happens if I disregard this alignment. You can ponder all you want as to why the face is out of perspective, but unless you diagram it, it may take you a while to discover that the eye is floating away.*

Views of the Eye

In Figure 48 you see a direct front view of an eye looking up with almost all of the iris showing. Due to the bulge of the cornea over the iris (as outlined in Figure 49), the upper lid is pushed up in the center. Both the upper lid and the whole eye opening become less angular and more round; even the line of the eyebrow is arched slightly. Whenever the eye looks up, the angular eye opening gives way to more circular shapes.

With this illustration, it's a good idea to point out that the pupil is the darkest spot on the head, unless the hair is very dark. The pupil, which is the opening into the eyeball, is dilated or contracted by the iris according to the varying degrees of light entering the eyes. The dilation of the pupil in this drawing is the most pleasing amount for a portrait. Notice that when the eyeball rolls up, the white (sclera) can be seen around and underneath the iris.

When the eye looks down, as in Figure 50, the lid's role as a cover for the eyeball becomes apparent. The upper lid conforms to the rounded shape of the eyeball itself and the lower lid folds under to become a dark recess. The eye opening is now in darkness, so the sclera is consequently very gray, with no luster showing. The brightest part of the eye is the rim of the lower lid. The lash tones intermingle with the iris, sometimes completely obscuring it, although usually a little black shows. Notice the overall shape of the eye opening; it appears slightly more angular as the upper lid starts to close. Figures 51 and 52 give you side views of the eye, Figures 53 and 54, three-quarter views.

Figure 55 demonstrates what makes an eye sparkle. The main light coming from the side strikes the glassy, moist cornea, producing a bright highlight bouncing off its surface. Of course, the transparency of the cornea permits some light to travel on inside the eyeball, where it illuminates the

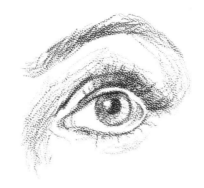

Figure 48. *Here you see a direct front view of an eye looking upward. Notice that the pupil is the blackest area of the eye, and indeed of the whole face.*

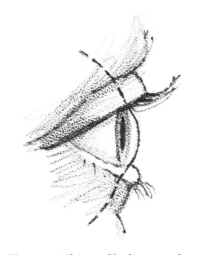

Figure 49. *This profile diagram shows how the eyeball bulges out at the iris. It also serves to point out the thickness of the lids; many students forget to demonstrate this.*

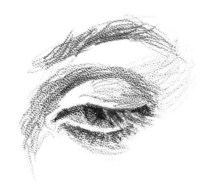

Figure 50. *When the eye is looking downward, the lid of the eye becomes apparent. Notice how it conforms to the roundness of the eyeball itself.*

iris on the opposite side. When doing a portrait, if you use multiple light sources of equal strength to light the sitter, this life-giving effect is destroyed. (See the chapter on lighting the sitter.) You can also see in Figure 55 how the flecks of color in the iris seem to radiate from the pupil opening. See Figures 56–58 for some structural diagrams of the eyeball and socket.

These drawings of eyes in Figures 59–62, with the eyeballs diagrammed below each pair, are intended to help you understand how the eyeball is situated within the socket so that proper tracking can be effected. By "tracking," I mean the placement of the eyes relative to each other so they seem lifelike and so they also appear to be actually focused on a definite place. Figure 59 is the position of the eyeballs if they are looking straight ahead at a fairly distant place or object. The white area (sclera) shows about equally on both sides of the iris. Figure 60 gives the position of eyeballs focused on something close by. They appear to be slightly crossed, which is exactly right, since the closer the object, the more the eyes cross.

In Figure 61, the head is turned with the eyes looking at you. Due to perspective, the farther eye seems a tiny bit smaller. Also, remember the overhead diagram of the eyeballs in Figure 58, which shows the curvature of the bone structure around the eye. Because of this curvature, and because this is a three-quarter view, you see much less of the white on the far side of the eyeball (see the diagram directly below).

When the eyes turn to the extreme corners, a strange thing happens (Figure 62). The farther eye can't seem to turn around as far (due to the limitations of the surrounding muscles), so its iris can't quite reach the inside eye corner. Since this is a front view, the amount of white showing is about the same in each eye.

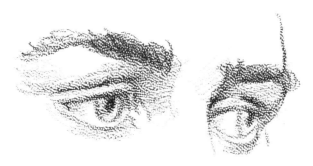

Figure 51. *Even as the head continues to turn, the X that aligns the eyebrows with the opposite eyelids continues to make the two eyes coherent.*

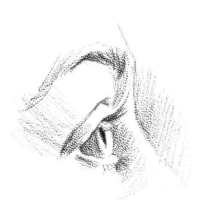

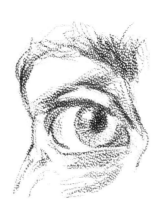

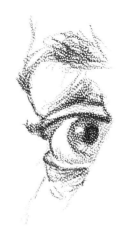

Figure 52. *A side view of an eye looking up, showing the upper lid folded a little under the overhang formed by the eye socket. The upper lid is pushed back when the eyeball rolls upward. The course of the eyebrow is clear here, starting at or slightly under the rim of the orbit, rising up over its rim and down again. Note how a convex shape, the eyeball, is suspended in a concave shape, the eye socket.*

Figure 53. *A three-quarter view of an eye showing you the shape of the lower lid as it meets the under-edge of the upper lid. In order to "turn" that eye around the "corner" of the face, you have to give a rounded shape to the outer side of the eye opening. However, the inside corner should still appear angular. Directly above the upper lid the tissue creases under the edge of the eye socket.*

Figure 54. *As the head turns even farther away, the eyeball and the lids begin to appear in silhouette. The thickness of the lids shows here. As in Figure 49, you can see that the thickest part of the upper lid is always over the iris.*

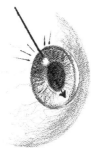

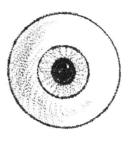

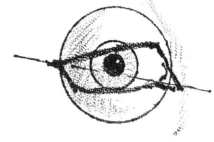

Figure 55. *Here's a diagrammatic explanation of what makes an eye sparkle. Because the cornea is moist and shiny, its surface reflects light, causing a highlight, or sparkle.*

Figure 56. *These two drawings diagram the eyeball. In order to estimate the sizes of either the iris or eyeball, figure that the iris is about half the diameter of the whole eyeball. The opening of your sitter's right eye will resemble this sharply cornered shape, with the outer corners aligning at a downward angle. This should remind you also that to show the roundness of the eyeball, shade it around the sides as in this illustration.*

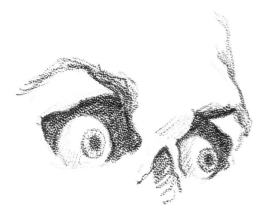

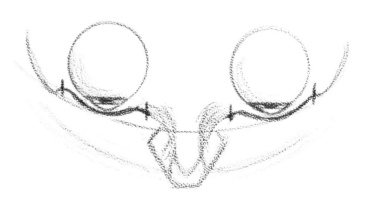

Figure 57. *In this imaginary sketch, the tissue over the eyeballs has been left off to clearly delineate the eye sockets (orbits) in relation to the surrounding area. Also, it shows the concave bed of the socket and how the eyeball is suspended in it.*

Figure 58. *One of the reasons that people often have problems in constructing both eyes together is that they forget that the plane of the face is a curve. In this overhead diagram of the positions of the eyeballs and nose, the startling thing to notice is that the eye openings (the spaces between the marks) slant backward. Keeping this in mind will help you when drawing and tracking the eyes in a turned head.*

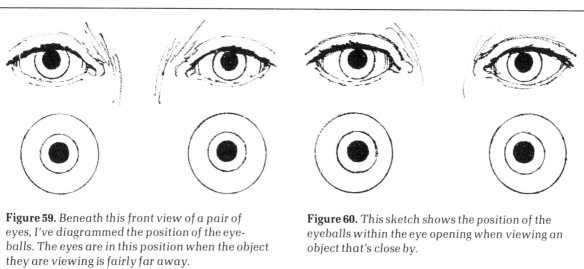

Figure 59. *Beneath this front view of a pair of eyes, I've diagrammed the position of the eyeballs. The eyes are in this position when the object they are viewing is fairly far away.*

Figure 60. *This sketch shows the position of the eyeballs within the eye opening when viewing an object that's close by.*

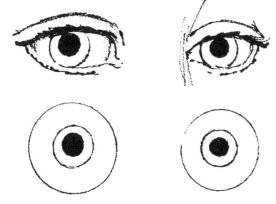

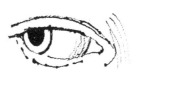
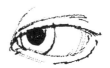
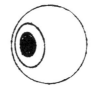
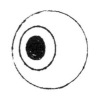

Figure 61. *Here the head is turned away, but the eyes are looking straight at you. Notice the position of the eyeballs relative to each other; because of perspective, the right eye seems smaller.*

Figure 62. *This is a view of eyes that are looking at a peripheral object.*

The Neck

Figures 63, 64, and 65 should be helpful in understanding the relation of the head to the neck and body. In the first place, you must remember that the shoulder plateau is *not* level. It slants forward and projects the head out toward the front. To estimate the arch of the back (generally seen in a three-quarter view), trace an imaginary line curving from the shoulder plateau to the point of the chin (Figure 63). But you want to be vigilant about this, since when a person sits for a while (as you'll discover with your sitters), they begin to sag. As the chin droops, the relationship between the bottom of the chin and the arch of the back changes. Figure 64 shows that the shoulder plateau ends at the collarbone, which encircles the neck. The two sternomastoid muscles attach to the collarbones and form the wishbone effect up and around the neck. Students sometimes make the mistake of drawing the neck straight up like a tree because of the perpendicular rise of the sternomastoid muscle in the side view of the neck (see Figure 65). The muscle is quite outstanding and you might mistakenly judge the whole neck area by its appearance. However, the neck is actually a bit wider at the top where it flares out at the back of the skull; in front, the neck narrows below the Adam's apple.

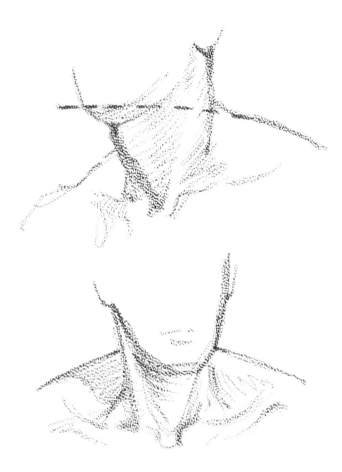

Figure 63–4. *These two sketches show the relationship of the neck and head to the rest of the body. In the top sketch notice how the shoulder plateau slants forward. This thrusts the head out in front of the body, as seen in the bottom sketch.*

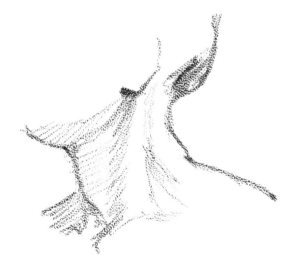

Figure 65. *Here you can see the almost perpendicular sternomastoid muscle which rises straight out from the body to the head. The attitude of this muscle sometimes causes students to draw the entire neck straight out from the shoulders instead of slanting forward.*

A

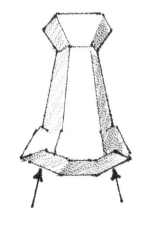

B

Planes of the Nose

The nose is easily drawn because it is a more stable structure than the other features. It could be described as having four main visible planes (Figure 66). The steps of construction start with a simple outline, Diagram A. The front plane slopes outward, widening as it does. The side planes lay up along the cheek and out at an angle, narrow at the top and wider below. In the next step, Diagram B, you see the keystone part at the top, which is actually an upside-down version of the nose but shorter. For the wings of the nose, Diagram C, I like to imagine that the two outer corners have been shoved up as the arrows indicate. Finally, in Diagram D, the edges are rounded and softened to complete the nose. For some views of the nose, see Figures 67–69.

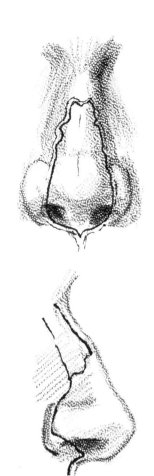

C

D

Figure 66. *Here are four diagrammatic shapes of the nose: (A) the front plane; (B) the keystone part that attaches between the eyes; (C) the "wings" of the nose, or nostrils; and (D) the entire nose assembled.*

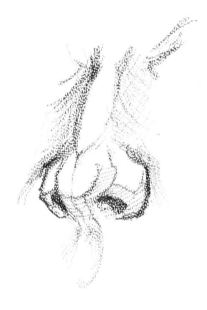

Figure 67. *An underside view of the nose illustrates the planes more clearly. Notice that the tip is rounded. The division of the nose structure is often made obvious by a line showing down the center. Unless this division is very prominent, I don't usually make an issue of it. It's an outward manifestation of the septum, or partition of the left and right cartilages. This separates into two ridges down to the lips, which should be suggested.*

Figure 68. *In these two views of the nose, the bone structure is outlined in black. On the top, the entire area outlined opens into the skull through the nostrils. The bottom (profile) sketch demonstrates the noticeable hump on many noses. The bone material ends here, and the rest of the nose is cartilage only. Any realistic drawing will show some evidence of this hump on a nose, no matter how slight. Of course, it's more obvious on men and older people.*

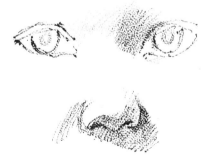

Figure 69. *The bump at the end of the nose bone doesn't show on children because it grows very slowly compared to the rest of the skull. (It seems to continue to grow our entire life.)*

The Ear

The construction of an ear can be worked out from a very simple cartoon idea. Though it may seem unscientific, I think it firmly establishes how the ear is fundamentally built. It's based on two letter shapes—C and S (see Figure 70). The outline of an ear is just a C shape slanted back slightly. For the right side of the head, it is in the correct position. Inside of that I draw the S shape, smaller but *backwards* on the right side of the head. Next, I add the various parts that make up an ear. They are all made of cartilage and have no simple comparable geometric shapes, so I'm forced to explain them in their anatomical terms. I'll only use a few of these terms in this case. The outside rim that curls around the ear down to the lobe is the *helix*. It twists slightly and turns in an irregular manner. The *antihelix* starts with two arms under the helix at the top of the ear and becomes one outward bulge descending to the *antitragus*. The hollow cavity is the *concha*, and it opens into the ear hole, which in this view and especially in a front view, is hidden. The flap in front that covers the ear hole somewhat, is the *tragus*; and opposite it is the *antitragus*, mentioned before. On the left side of the head, the ear of course can be constructed from the letter shapes C and S, but remember that the C is backwards and the S is correct.

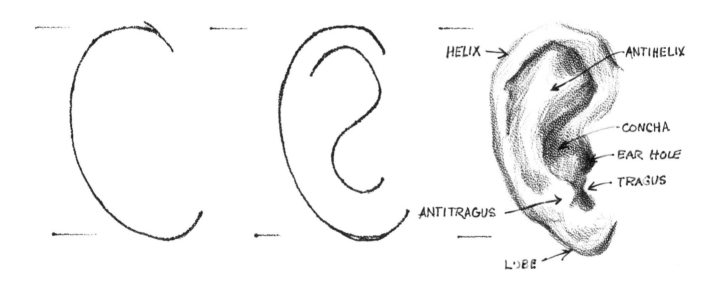

Figure 70. *Starting from the left you can see the two diagrammatic shapes that make up the ear: the C and the backward S, respectively. In the sketch on the right you see a complete ear with its anatomical parts identified.*

The Mouth

In Figures 71 and 72 you can see simplified diagrams of the mouth. In the front view of the lips (Figure 73), the first noticeable thing is that the upper lip is thinner than the lower one. In the outlined segmentation below, you can see that the lips have a rather exact shape. The upper lip has a central dividing line thrusting forward, called a *tubercle*. The bottom lip has three planes, the central one and two sloping sides. Notice that the central segment is pinched in the middle, causing the lower lip line to arch up a little. For other views of the mouth, see Figures 74–75.

Lips become narrower and elongated in a smile (see Figures 76 and 77). The separation line between the lips turns up only very slightly in the corners. The flesh above the corners of the mouth pulls back into shadow. Although

they're stretched out, the segments are still there. They're not as obvious, of course. The lower lip loses its independent shape and is influenced more by the teeth underneath. The little "shelf" formed by the lower lip is now drawn back and flattened, so that the entire lip and the fleshy area directly underneath the lower lip are lighter. The short, deep shadow under the mouth now becomes a flatter, continuous one extending around and up to the separation of the lips.

I have been illustrating my discussion of the mouth and its parts with sketches of the female mouth. In Figures 79–81 I've drawn a man's mouth and chin, and that of a child. Although the basic shapes remain, there are modifications in them depending on the sex and age of your sitter.

Figure 71. *A side cutaway of the mouth and chin would show the teeth forming a gentle horizontal curve, conforming to the tumbler-like shape of the chin area.*

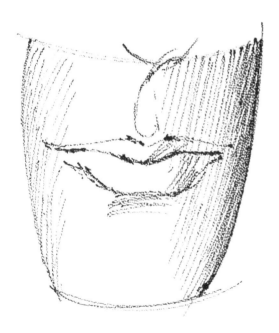

Figure 72. *This rounded-out shape of the face, similar to the side of a tumbler, is a simplified version of the whole mouth and chin area.*

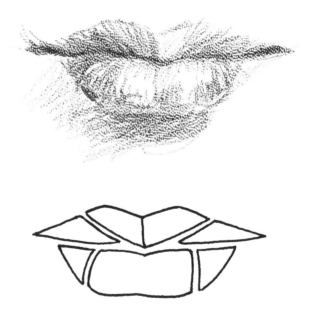

Figure 73. *Here's a front view of the mouth with the lips closed. Below it I have diagrammed and separated out the main shapes of the mouth and lips.*

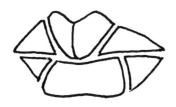

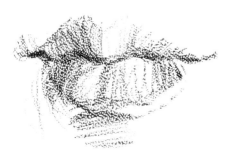

Figure 74. In a slightly three-quarter view of the mouth, the segments remain intact. You'll notice, probably in this view more than others, that the color of the lower lip does not always continue to the lower boundary. Often it looks as if there's a tiny fleshy path around the bottom.

Figure 75. The profile view of the mouth gives you an idea of the contrast between the angles formed by the upper lip, lower lip, and the separating line. The ideal mouth recedes in profile from the shelf on top of the lips to the separating line between the lips to the underside of the lips.

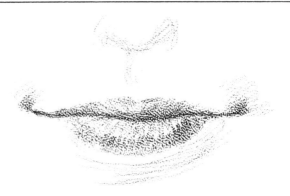

Figure 76. Many people have a natural smile with their mouth closed. You may want to show this in a portrait. In this smile the lips are pulled and elongated.

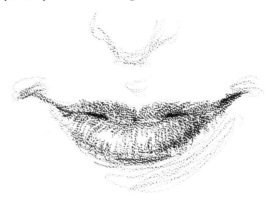

Figure 77. This is looking down on an almost completely closed, smiling mouth. It's open just enough so that the two main upper cutting teeth are in view. The only reason for the curve in the corners of the lip line is to show the basic outer curve of the mouth area.

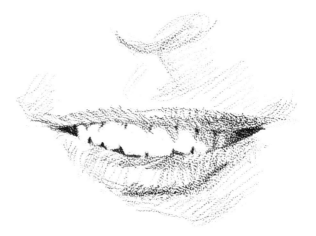

Figure 78. The expanse of teeth showing is narrower than the smiling mouth opening so that the back teeth are invisible, leaving dark voids in the corners of the mouth. The shadows cast by the upper lip onto the teeth and the spaces between the teeth should be rendered. Don't delineate these spaces too much, since lines all the way down seem to give the teeth a decayed look. The gum line above the teeth often shows and is similar to the upper lip in tone and color.

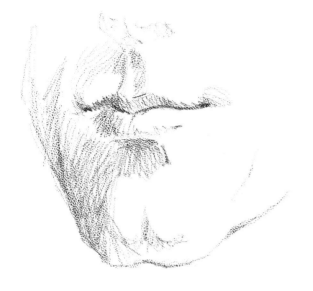

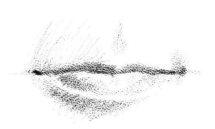

Figure 79. *(Above) A man's lips with a pleasant expression. Since some men have very thin lips and possibly no demarcation of the red parts, their lips just seem to blend right into the flesh. I think you should show a tiny bit of proof that a basic lip formation exists, but you skate on thin ice because if you go too far you'll lose the character of the sitter.*

Figure 80. *(Left) The whole construction of the man's mouth and chin indicates thinner, lighter-toned red parts and more squares and angles to the jaw. The bony subsurface of the man's chin is more apt to influence the drawing than a woman's.*

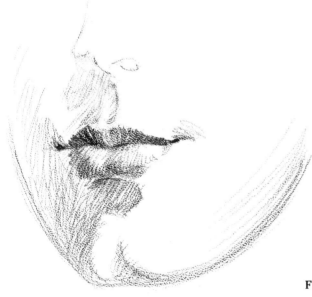

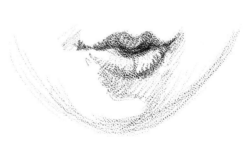

Figure 81. *(Above) The formation of the child's mouth, as far as its construction, is exactly as it will be in any stage of life. The only difference (other than the size) is the exaggerated bow effect of the top lip and the fuller, rounder bottom one.*

Figure 82. *(Left) In contrast to the man's jaw and mouth region, the woman has smoother, darker, and more ample red parts to the lips. The entire jaw has a smooth line; this line along the jaw is a dangerous area—it can add years to a woman's looks if the smoothness isn't maintained.*

3. Hand Structure

If the head is the star element in your portrait, then the hands are the next in the list of supporting players. You may have trouble when you first attempt to draw hands; you might even resort to hiding them in pockets or behind the subject. But don't fight it, a little study will convince you that hands aren't so difficult after all. Drawing hands well separates the amateurs from the professionals, and besides, if you haven't noticed, hands have as much individual character as faces. Sometimes they can tell you much about a person, though one can be fooled by them too. I've known people who didn't have the long, slender hands of an artist, but short, stubby fingers instead, and they could paint rings around me with my long fingers.

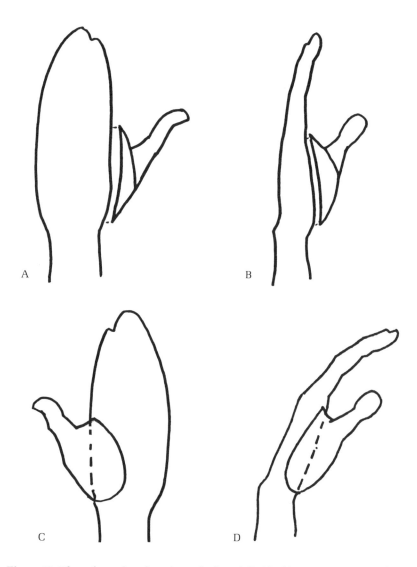

Figure 83. These four sketches show the hand divided into two parts, with the palm and fingers as one unit and the thumb as another, separate, unit. (A) The back side shows the shape of the metacarpus and fingers. The thumb is pulled away to show its triangular base and digital joints. (B) The side view opposite the thumb, which in this view appears to be attached to the palm side. (C) The palm facing us, showing exactly how the thumb base is attached to the palm. (D) The thumb appears foreshortened and attached to the side of the hand.

Looking at Hands

Unlike the basic shape of the head, the hand has many shapes—thumb, fingers, palm area—that all look different depending on their movements and positions in relation to each other.

To clarify your thinking about hands, let's use a simplified version of the hand—separated into two distinct parts. In Figure 83 you can see the hand and fingers without the thumb assembly—as a paddlelike shape. The thumbside of the hand is straighter while the outside gently curves. (The notch at the top is just a suggestion of the index finger separating from the rest.) In each of these positions the thumb is seen as a separate unit, attaching at an angle, on the side and on the back of the paddle. Sketch A of the topside of the hand shows only a flat triangle for the base of the thumb plus its metacarpus and two phalanxes. In sketch B the thumb is on the far side, with more of the base of the thumb showing but with the thumb itself angling away from you. On the palm side, sketch C, the thumb and its base overlap the whole hand. Sketch D illustrates how the thumb attaches to the side of the hand as it faces the palm.

To carry this thinking into actually sketching the hands, I'll disregard the thumb at first and draw in the contour of the hand with perhaps just a finger, like the little one, notched. In all of these sketches in Figure 84, I've just indicated the contour of the hand and left the thumb until later. It's even a good idea to leave the ends of the fingers open at first. Now it's easier to visualize how the thumb fits on as a separate piece with its own peculiar shape.

A "V" shaped relation of thumb + hand

Figure 84. *These various views of the hand are ones that might be sketched in short time poses. In these, you can more accurately delineate the hand by seeing it without the thumb, contouring around and through the thumb. You can see the proportions of the hand and fingers as a unit more easily this way.*

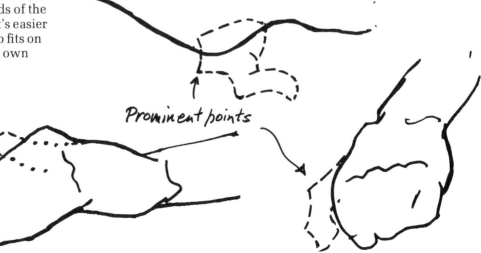

Prominent points

Anatomy of the Hand

Figure 85 is a diagram of the hand, giving you some anatomical terms to help you distinguish the different bones and understand how the hand works. For instance, the phalanxes are snugly joined so they are only able to move toward the palm side of the hand. The joints between the phalanxes and the metacarpals are such that the two can move freely in all directions with respect to each other. The rocklike carpals are locked too tight to permit any independent movement in the area, but are designed to withstand a certain amount of shock between the hand and arm bones. Of course their position on the top of the radius and ulna permits quite a bit of free movement there. It's important to realize that the joints between the phalanxes and metacarpals are about an inch below the web of flesh formed by the fingers.

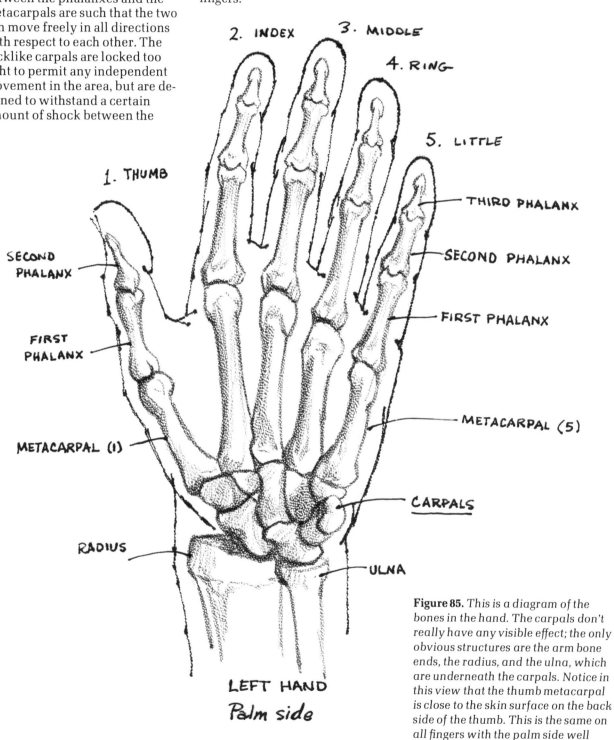

Figure 85. *This is a diagram of the bones in the hand. The carpals don't really have any visible effect; the only obvious structures are the arm bone ends, the radius, and the ulna, which are underneath the carpals. Notice in this view that the thumb metacarpal is close to the skin surface on the back side of the thumb. This is the same on all fingers with the palm side well padded.*

Muscles and Proportions

In Figure 86 you can see how the muscles affect the form of the hand. With the aid of arm muscles, they help bend the fingers. Cupping the hand and pulling the thumb across the palm is done with the four muscles shown on the mound of the thumb. The groups on either side of the palm are connected by the tendon of the palm.

Another thing to observe in this diagram is that the joints of the fingers are lined up in arc shapes A, B, C, and D. The arcs are increasingly wider toward the tips. You'll note too, that the middle finger here tends to slant toward the little finger side (although sometimes it's the straightest finger). Visually, the other fingers lean toward the middle finger "in reverence."

Some proportions for the hand are: the hand's length from the carpals to the tips is comparable to the length of the face from the chin to the forehead; half the length of the hand consists of fingers and that dimension is equal to the width of the hand across the knuckles.

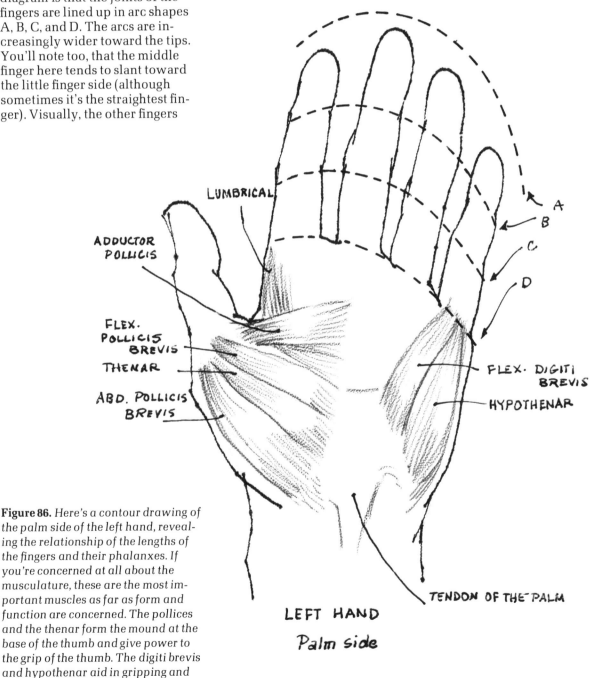

Figure 86. *Here's a contour drawing of the palm side of the left hand, revealing the relationship of the lengths of the fingers and their phalanxes. If you're concerned at all about the musculature, these are the most important muscles as far as form and function are concerned. The pollices and the thenar form the mound at the base of the thumb and give power to the grip of the thumb. The digiti brevis and hypothenar aid in gripping and curling of the little finger.*

LUMBRICAL

ADDUCTOR POLLICIS

FLEX. POLLICIS BREVIS

THENAR

ABD. POLLICIS BREVIS

A

B

C

D

FLEX. DIGITI BREVIS

HYPOTHENAR

TENDON OF THE PALM

LEFT HAND
Palm side

Hand as Block Form

The space age gives vent to our imagination so that we can visualize things in robot forms. It should be easy to imagine the hand as in Figure 87. Or to reverse the idea, use these blocks to visualize what a hand is like or how the forms can be simplified.

The wrist is on a somewhat higher plateau, so that the overlapping joint inclines down to the back of the hand. (Notice how the ulna sticks up on the far side of the wrist.) The form that is the back of the palm, though composed of separate metacarpals, appears solid. It seems to be the nucleus from which everything else radiates. The small protrusions on top represent the knuckles, which are usually evident. The fingers, separated at their joints, are indicative of the squarishness of the first two phalanxes and then the rounded tips. The whole assembly of the thumb is shown, fitting as it does, at an angle with only two phalanxes. Visualizing any anatomy in this fashion is O.K. as long as your drawings don't impart a wooden look.

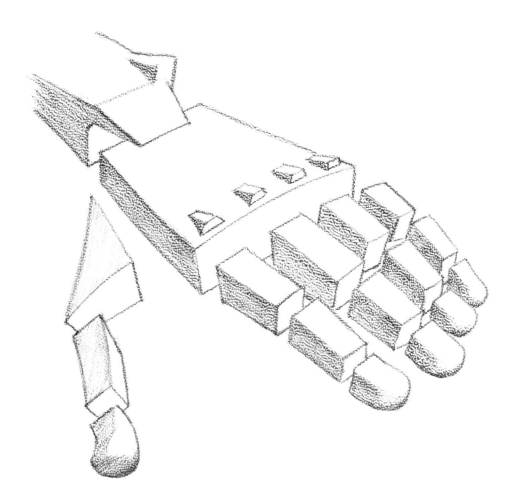

Figure 87. *If it's your thing to visualize the figure in blocked form, this should help you. When there's a tendency for a form to be squarish, then it's O.K. to see it this way, as with the hand. However, care should be taken that you don't carry this thinking too far.*

A Woman's Hand

Delineating the outside contours, as I suggested for sketching the hand quickly, gives an appearance of gracefulness to the hand also. In Figure 88, a woman's hand hanging over the edge of a chair arm shows this linear flow. The fingers taper gently and even though their tips are rounded, they seem to come to a point, as on the thumb. The pointed, overhanging nails hide the bulbous ends. A woman's fingers are more apt to curl than a man's, especially the little finger. The knuckles appear as little pointed shapes with very angular shadows. A young woman isn't likely to want the veins and tendons to show, even if they do. Unhappily this is a burden of aging. A side view of a woman's hand, Figure 89, shows the gracefulness of tapered fingers. At point A, you can see the V-shaped relationship between the thumb and palm. Point B is the metacarpal prominence noticeable on all hands. At point C, the tendons on the back of the hand bridge the wrist.

Figure 88. *(Above) A woman's hand falls into a pose that shows the natural bend of the fingers. Making any visible part of the knuckles more angular, sort of diamond-shaped, contributes to this tapering feeling. Also, the nails extend over the edge of the fingers, and pointed nails heighten this effect.*

Figure 89. *(Left) The mounds of the palm affect the shape in a side view of the hand. This illustration again shows the progressive slope of the finger separations from the inside to the outside of the hand. A is the relationship of the thumb and hand. B is the prominence of the metacarpal. Notice at C that the muscle doesn't kink at the wrist, but instead, the tendons on the back of the hand bridge the wrist smoothly.*

A Man's Hand

A common hand pose for a man is with the hand resting on a thigh, as in Figure 90. You can see what happens when the fingers and hand curve around the surface of the leg. The dip from the back of the hand to the finger plane is very obvious here on the little finger, and in lessening degrees on the rest. Notice that the little finger tucks under the ring finger at the third phalanx, evidence of how the outside fingers curl toward the middle one. The nail of the fourth, or ring, finger turns forward, as the fingers and hand conform to the round shape of the leg. The veins and tendons form a light and shadow pattern on the back of the hand, with the tendons manifesting themselves more strongly. The tips of the third phalanxes are more squarish than those of the woman's fingers.

Figure 91 is another typical hand pose a man might have. Men tend to feel awkward when they are posing, and their hands, held stiffly with the fingers closed in a formal row, are a giveaway. I guess it's a symbol of their unwillingness to show any emotion.

The anatomical importance of this pose is the bending action of the fingers, which forces the knuckles up. Figure 91 is also a good example of the spacing between the knuckles and the divisions of the fingers. Notice that when the hand is resting on something, as in this pose, the plateau of the back of the hand appears to arch. This is because the index and middle fingers have to coil underneath the thumb pad and thus thrust up the back of the hand. Due to perspective, the back of the hand is foreshortened, compared with the first phalanxes. The tendons and the veins are hardly identifiable, though some feeling of the strength of the tendons should be shown.

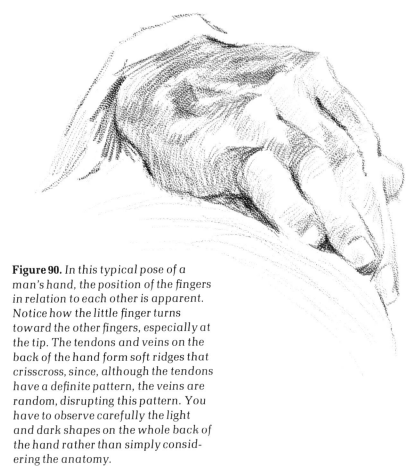

Figure 90. *In this typical pose of a man's hand, the position of the fingers in relation to each other is apparent. Notice how the little finger turns toward the other fingers, especially at the tip. The tendons and veins on the back of the hand form soft ridges that crisscross, since, although the tendons have a definite pattern, the veins are random, disrupting this pattern. You have to observe carefully the light and dark shapes on the whole back of the hand rather than simply considering the anatomy.*

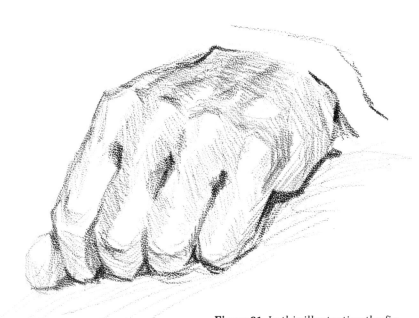

Figure 91. *In this illustration the fingers seem to be an even row, but you can see that the varying lengths of the phalanxes, and the fingers' inability to curl under the same way, make the hand tilt over. The space between the finger separations and the knuckles is obvious here.*

The Squareness of Fingers

If you look at the tip of one of your fingers, several things become apparent. First, the flesh between the main knuckles and the finger separations forms small, inverted V-shaped webs (Figure 92). You may not have realized it, but the shafts of the fingers are squarish with the edges only slightly rounded off; just the tips, then, are quite rounded. The topside of the finger with the nail is less curved than the underside. The nails of a man's or child's fingers are often shorter than the fingertips, whereas a woman's nails often extend over the end, accentuating the slenderness of the fingertips.

Notice how the skin covering the knuckles wrinkles when the fingers straighten; this extra skin is needed to accommodate the joint when it's bent. When the fingers are flexed, the skin forms circular ridges at the junction of the first and second phalanxes; at the joint of the second and third phalanxes the skin just wrinkles straight across the finger. These details add to the realism of a hand; yet the individual preferences of the person you're drawing, plus the manner of your rendering, will determine how much of these details you incorporate.

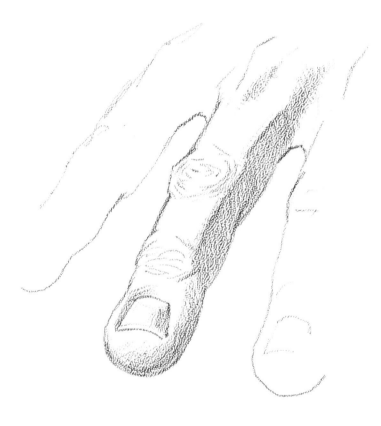

Figure 92. *An end-on view of the finger emphasizes its squareness, although the top side of the finger is slightly rounded and the bottom side is quite rounded out by its fat pads. Notice how the skin covering the triangle-shaped incline between the fingers forms a web, and also how the skin on top of the finger "pools" and wrinkles when the fingers extend.*

Children's Hands

The hands of children are miniature adult hands only in some respects. The underlying structure is the same but the emphasis is on shorter fingers and a plumper metacarpus. The infant's hand in Figure 93 is indicative of this difference. Anyone who looks at a baby's hand marvels at the perfection and the tiny duplication of the adult's hand, especially in the nails and fingers. Then you see the difference—the chubbiness of the back, the thumb pad, and the fingers near the base. There's no evidence of boniness. On the back of the hand, the attachment of the skin to the knuckles pulls in the layer of fat to form dimples. The junction of the hand and wrist is marked by a bracelet crease of fat. On the palm side, the muscle mounds at the base of the thumb and the hypothenar are quite plump and powerful (Figure 94).

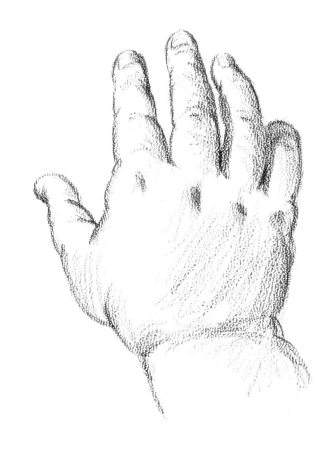

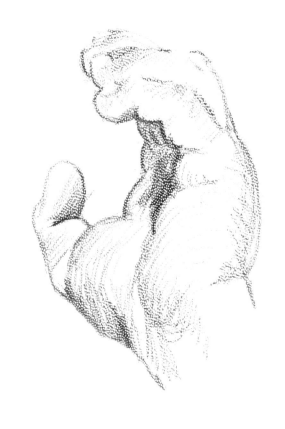

Figure 93. *(Above) The baby's hand is mostly little mounds of fat, so much so that the knuckles are buried and can only be located by dimples. The nails are perfect miniature adult ones. The fat of the hand and the arm meet to form a crease around the wrist.*

Figure 94. *(Right) In this view you can see why the grip of a child can be quite powerful for its size. The development of the muscles in the palm is quite significant, and together with the fat pads, gives the characteristically puffy form to a baby's hand.*

Fine Points of the Hand

Some *special* points have to be considered to make a hand look professionally drawn. The paddle-like shape of the hand is nearly always bent. As shown in Figure 89, the fingers have a natural tendency to curl and it's only with tension that you can straighten the hand. If the hand and fingers are nearly straight, there are distinct angular features in the side view (see Figure 96). The wrist plane drops into the back of the hand, as described earlier in Figure 87. The knuckles slope to the finger plane and the joints of the fingers themselves form angles.

Since the length of the metacarpals varies, the hand appears trapezoidal (Figure 97). If you'll look at Figure 98, you'll realize the effect this has on the hand gripping a straight object. The knuckles form an angle (dotted line AB), rather than a line parallel to the wrist. In performing this simple task the fingers give you a new consideration, that is, the angles at which they slant from the metacarpals into the palm. You can also see in Figure 99 that when the fingers start this curling, gripping maneuver, they appear to be moving toward their leader, the middle finger. (Notice how the arrows follow their directional tendencies). Therefore, the fingers have not only a natural tendency to lean towards the middle finger (see Figure 86), but also they curve together as a result of the varying lengths of the metacarpals.

Figure 100, showing you the supine position of the hand, is another instance of the double curling proclivity of the hand, with the index finger tensed somewhat in a gesturing manner. The mass of the thumb and its base is significant here also for its squarishness. Figure 101 is a quickie diagram to belabor the important points that make a hand believable. In it, I stress the arch of the back; the step down from that plateau to the fingers; the squarishness of fingers, and finally, their warp to the middle finger.

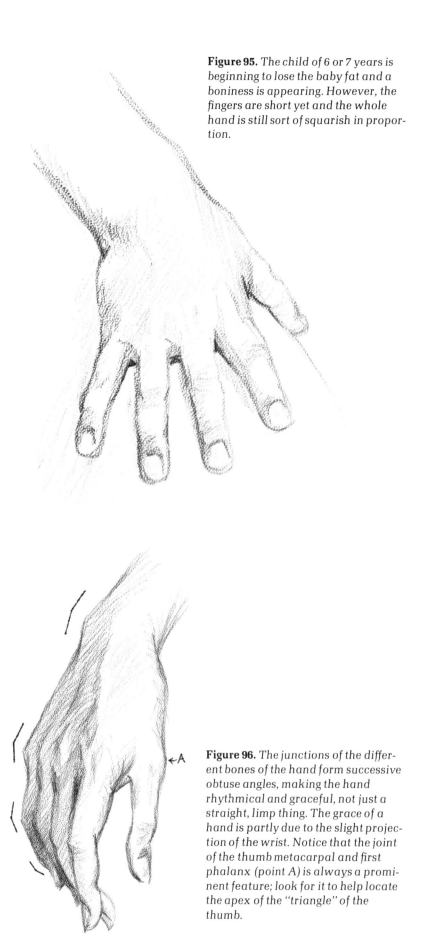

Figure 95. *The child of 6 or 7 years is beginning to lose the baby fat and a boniness is appearing. However, the fingers are short yet and the whole hand is still sort of squarish in proportion.*

Figure 96. *The junctions of the different bones of the hand form successive obtuse angles, making the hand rhythmical and graceful, not just a straight, limp thing. The grace of a hand is partly due to the slight projection of the wrist. Notice that the joint of the thumb metacarpal and first phalanx (point A) is always a prominent feature; look for it to help locate the apex of the "triangle" of the thumb.*

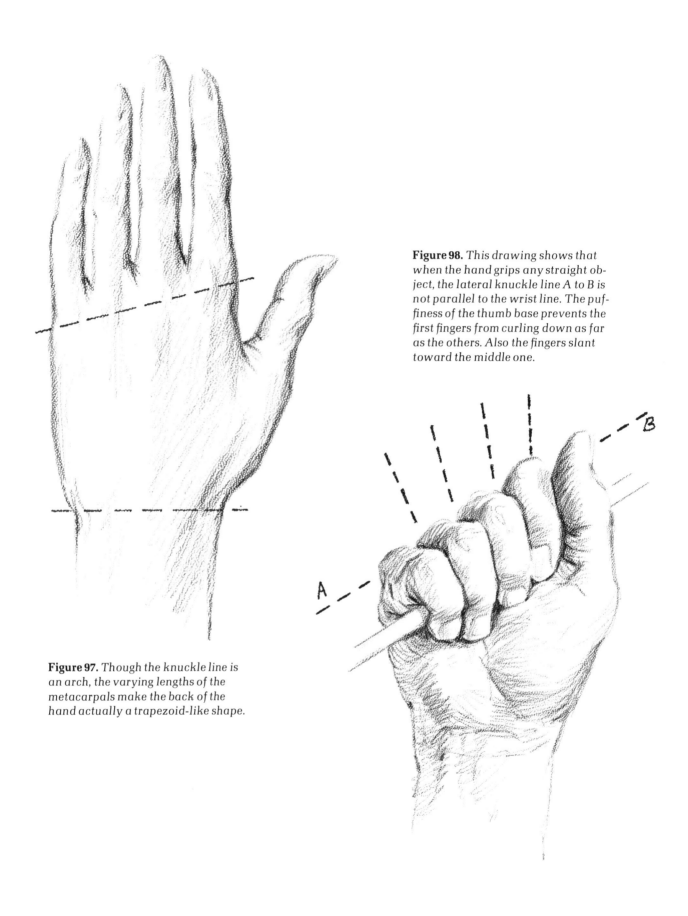

Figure 98. *This drawing shows that when the hand grips any straight object, the lateral knuckle line A to B is not parallel to the wrist line. The puffiness of the thumb base prevents the first fingers from curling down as far as the others. Also the fingers slant toward the middle one.*

Figure 97. *Though the knuckle line is an arch, the varying lengths of the metacarpals make the back of the hand actually a trapezoid-like shape.*

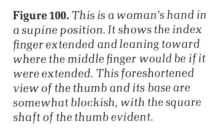

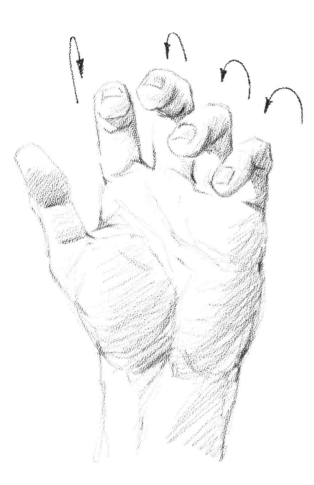

Figure 100. *This is a woman's hand in a supine position. It shows the index finger extended and leaning toward where the middle finger would be if it were extended. This foreshortened view of the thumb and its base are somewhat blockish, with the square shaft of the thumb evident.*

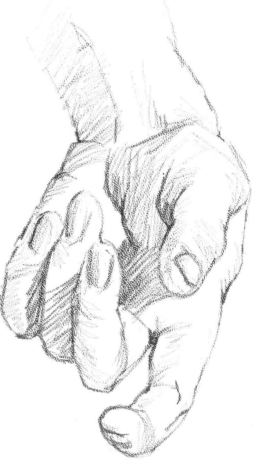

Figure 99. *Another demonstration of the directions the fingers take as they curl. The arrows show that they close toward each other. This point can't be stressed too much.*

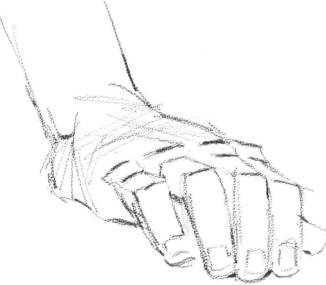

Figure 101. *Re-emphasizing the direction of the fingers in this sketch should strengthen my case for insisting that you observe this carefully so that the hand you draw becomes believable. Note the arch of the back of the hand and the step down from there to the finger level.*

4.
Lighting the Sitter

If you control the type of light that will illuminate your subject, your drawing begins to develop before you've lifted the pencil. If the subject is properly lit, masses of form are presented in the clearest way. In drawing portraits, you're not concerned with color, only with value changes.

I've found that the harsher a light is (within reason), the better it breaks the form into visible planes. Soft light blends all the values together into mush. To obtain this hard, "contrasty" look, use a single light source, preferably one that illuminates as a theatrical spotlight does, with a sharp focus. A photoflood reflector doesn't quite do this—the shadows aren't as sharp—but it's the most economical lighting source for the artist. In descending order of usefulness are fluorescent and daylight bulbs. A large skylight with north light may be great for the painter's easel, but that same light will flood the sitter with a soft light that I find difficult to draw from. If you have a north light, try to get the sitter back far enough out of the light so that you can train a spotlight on him. This will give you the highlights and shadows very clearly.

A portrait done in a full range of tones can't be *drawn* with the form broken up by lights from all directions. Yes, it's possible to *paint* such a portrait in color because a different color can be used for the second light source. But a drawn portrait, relying only on tone, should have its subject illuminated with just one light. A

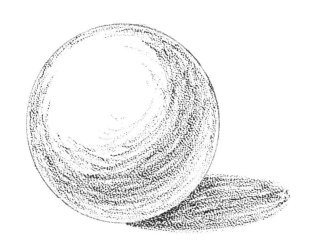

Figure 102. *A ball with one source of light clearly demonstrates roundness. A natural reflected light from the ground helps.*

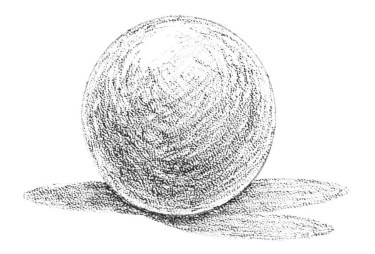

Figure 103. *By having two or more light sources, the form is gradually being destroyed.*

weak fill-in light for the shadows is permissible.

The analogy to the light on a ball or egg is an old but reliable one. The most striking way to show round or ovoid forms is with a single light (see Figures 102 and 103). More than one light destroys the form. This roundness is similar to the basic shape of the head, as well as its prominences: the eyeball, the nose, and the muzzle—the area between the nose and the chin, including the mouth—as shown in Figures 104 and 105.

Directing the Light

The direction of the light is the next consideration. Positioning the light in front of the sitter, above and slightly to one side of him (providing he's only slightly turned) best illuminates the whole head as a basic round shape. With such illumination, the forehead will be the lightest part, as in Figure 106. A shadow will be on one side of the nose and underneath it (Figure 107). The eyelids, covering the eye protruding from the socket, will be round too (Figure 108). The area under the upper lid will be a dark line, emphasized in some sitters by dark lashes; this indicates the thickness of the lid over the eyeball. The eyeball will have shading similar to a ball shape, as in Figure 109. In Figure 110 (and as described in Chapter 2), a one-source light will give a sparkling, lifelike look to the eye. You can indicate the thickness and shape of the rim of the lower eyelid with a highlight (see Figure 111). The planes of the lips (Figures 112 and 113) are outlined from top down as dark, light, dark. The lateral and vertical protuberance of the whole mouth area, and also of the eye structure, is apparent with this lighting (Figure 114). Because the neck goes back under the head, it appears in semidarkness as shown in Figure 115. A shadow cutting across the neck at an angle shows the projection of the head and the shape of the neck. The simple kind of light described here displays the head and its parts in their most natural and dramatic form.

Figure 104. *The ball-like shape of a human head is more obvious and easier to perceive when subject to a single light source.*

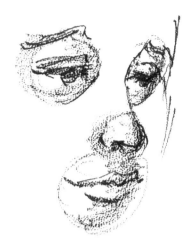

Figure 105. *Individual parts of the face have ball-like structures.*

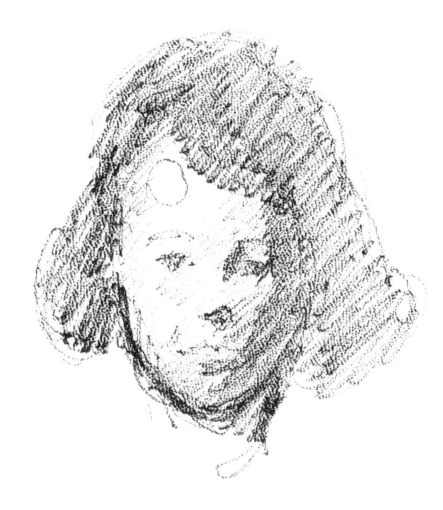

Figure 106. *A light above and to the side strikes a spot on the forehead and falls off around the rest of the (round) shape.*

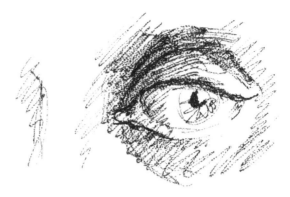

Figure 108. *This kind of light is especially good for showing the construction of the eye. Here the protruding eyeball, lid coverings, and hollow of the eye socket are demonstrated.*

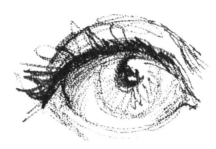

Figure 107. *A nose lit from the side and above projects nicely from the face due not only to the side shadow but the cast shadow as well.*

Figure 109. *A light from above makes an ideal heavy shadow line on the upper lid.*

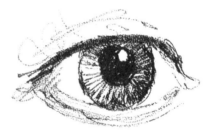

Figure 110. *The transparent quality of the cornea is much more clearly evident with one light. See Figure 55 (Chapter 2).*

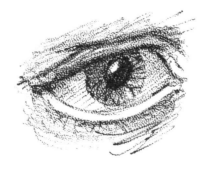

Figure 111. *In a view from above, the lightest part of the eye seems to be the rim of the lower lid.*

Figure 112. *An overhead light vividly displays the alternating planes of the lips as we're accustomed to seeing them in daylight.*

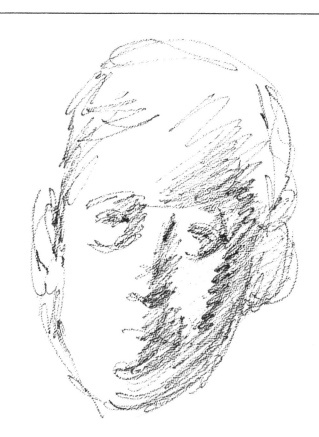

Figure 114. *The total head shape and features all have their protruding shapes illuminated clearly with this single light.*

Figure 113. *Here in the side view the overhead light gives the lips the same planes as in Figure 112.*

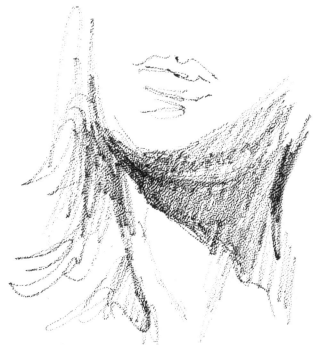

Figure 115. *When lit from above, the shape of the neck is shown by its shadow as it curves back under the head to the shoulders.*

Overcoming Problems by Altering Light

The light source might have to be tried in different positions to circumvent certain difficulties. One of the most common problems occurs when a person wears glasses and wants to wear them in the portrait. The heavy-rimmed glasses are the worst because they cast large shadows precisely across the eyes (Figure 116). One solution I've found is to drop the light from a high position down onto a level with the eyes (Figure 117). Should this cause too wide a nose shadow, move the light farther out in front of the sitter, or simply *eliminate* the shadow from your drawing.

Don't worry about the light hurting the sitter's eyes; if you subconsciously stew about that, you can't concentrate on the drawing. I've used strong photoflood bulbs without too many complaints. However, if the subject starts to squint because of the light, you'll have to use a weaker one or move it farther away—but you can't always avoid torturing your sitter in some way.

Lighting Women and Children

Be careful how you light women and children, especially with regard to the nose. It isn't desirable to overdramatize the size of the nose; overemphasizing its size will age children, especially (see Figures 118 and 119).

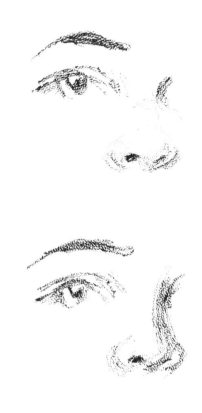

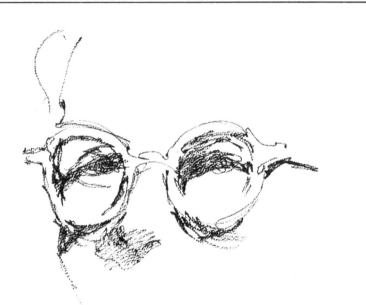

Figure 116. *Glasses are murder because of the shadow cast by the frames over the eyes rather than because of the presence of the lenses.*

Figure 118. *A child can age beyond his years if the bridge of his nose is too well defined by light.*

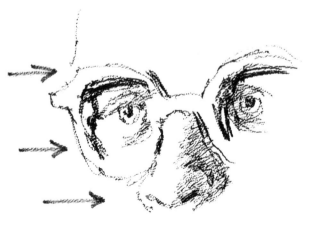

Figure 117. *Move the light to a lower position if necessary to get the shadow of the frames off the eyes.*

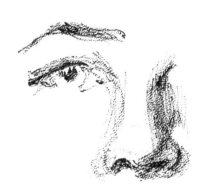

Figure 119. *A woman's nose can also seem larger and age her if it's too strongly illuminated from the side.*

When to Move the Light Behind

If your subject has a more interesting three-quarter or profile side, you might have to try another lighting angle. Lighting in the conventional front-above manner will still give the total round form, but it may wash out the shape of the features (Figure 120). Move the light farther around toward the sitter's back so that you see shadow sides of the face, nose, etc., as in Figure 121.

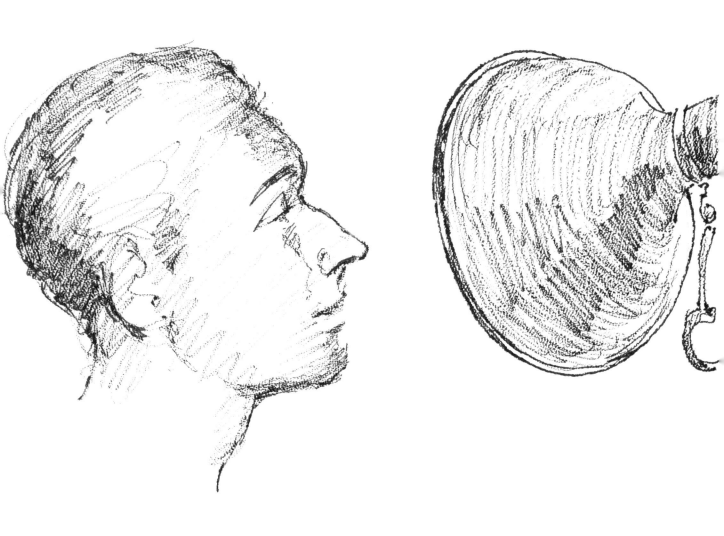

Figure 120. *A light placed too directly in front of the subject (from your point of view) can result in only enough shadow to outline the edges slightly.*

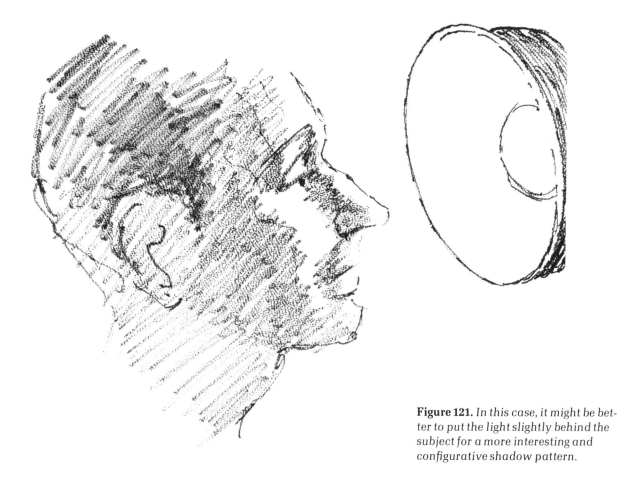

Figure 121. *In this case, it might be better to put the light slightly behind the subject for a more interesting and configurative shadow pattern.*

Lighting the Rest of the Figure

When the problem of lighting the head is solved, showing its shape and planar surfaces clearly, the illumination on the rest of the figure (torso and hands) is at the mercy of that light. If these don't look right, all you can do is reposition them in the chosen light until they satisfy you. It should be obvious that altering the light while drawing the different parts of the figure will make the finished portrait jarring to the viewer.

Photographic Lighting

The principles of lighting are the same whether you work from live models or from photographs. If you're confronted with the problem of working from photos taken by a photographer who's not an artist, I pity you. Most publicity photos, taken with a flash, produce such violent contrasts of light and shadow that the forms are destroyed. If you can draw a portrait from such a photo and still make it look like the portrait subject, you have a mysterious gift or you're just lucky! Most commercial portrait photos distort the sitter in another way; they're usu-

ally soft and mushy, and all definition of planes is gone.

Use every persuasive argument you can to get the sitter to pose for your photos. Photos taken with a flash are sharper than floodlight photos, but to minimize the violent contrasts you'll have to get a rig to permit the flash to be moved away from the camera and not too close to the sitter. I have a remote flash attachment which fastens to a lightstand with enough cord to move it anywhere around the sitter. The disadvantage with these photos is that you aren't able to determine exactly what the shadow pattern will look like. You can solve this by temporarily substituting a Polaroid camera on your tripod to record how the flash hits the subject.

You'll have to decide for yourself whether these photographic procedures will go against your principles. They have to be used intelligently and not as substitutes for observation. For one type of sitter at least—young children—you can preserve your sanity by using photos. But use your own, not those typical "cute" photos from local portrait photographers.

5.
Composing the Portrait

Some consideration should be given to where the drawing is going to be located on the sheet of paper or board. The head is the pivotal point of interest because of its dominance in size and importance. If you're going to do a head only, floating on a plain background, then place it slightly off-center, as in Figures 122 A and B. A spot to the left and above-center is the most pleasing location. Although it's conceivable that in an offbeat pose and drawing, the head could face out of the page, in a three-quarter or profile pose as in Figure 123A, the composition seems better balanced if the head is looking into the page and not out (see Figure 123B). In the conventional profile pose with the head facing into the page, a very dark vignette background around the features in profile is effective (Figure 124).

Balance is really the key to the whole picture. For instance, if there's to be some background, or more of the figure (arms and hands) visible, then placement is quite important in that respect. Hands are used as a *counterbalance* to the head, as demonstrated in Figure 125A. If there aren't going to be any hands in the picture and yet there's quite a bit of space below the head, some sort of pattern can be used as a balance (Figure 126).

Sometimes after I've finished a drawing—even though I thought I'd placed the figure precisely where it should be—I discover that the head or hands are throwing the composition off-balance, or

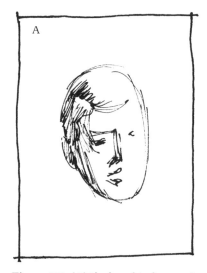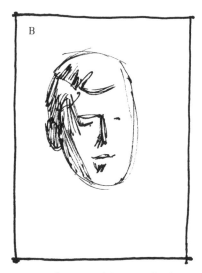

Figure 122. *(A) If a head is drawn dead center on the page, it's not only disturbing, but also not esthetically pleasing. (B) Here the head is placed to the left and slightly up. This has been traditionally established as the most pleasing spot to the eye.*

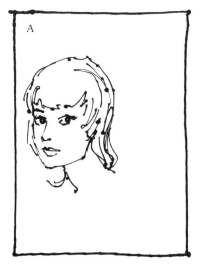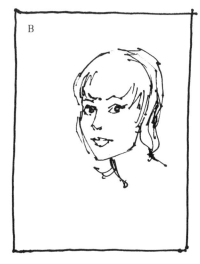

Figure 123. *(A) If a head is in either a three-quarter or profile view, it will face toward one of the side boundaries. In this position, it seems to face out of the picture. (B) It would be better to move it over to have it face into the picture, unless some eccentric composition is desired.*

maybe a hand has gotten too close to the edge (Figure 125B). If the drawing has gone well and there are things in it I couldn't possibly recapture in another try, I correct its composition by cropping unwanted parts with a mat. Of course, I must have left enough paper around the drawing's edges to do so. It's a good idea to work on a piece of paper or board that's larger than the final size.

Composing More than One Figure

When you've got two or more figures in a drawing, composition becomes a hassle. Of all multiples, three figures are the easiest to arrange. Two figures are too evenly balanced, unless one is an adult and the other a child. Four figures are a little better than two, but they are still an even number. Composing several figures is a matter of how you arrange them as a group as much as where you put them on the paper. *Within* that group there will be arrangement problems, as you'll see in later

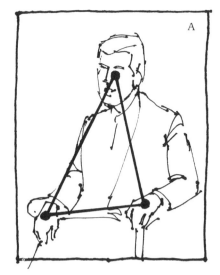

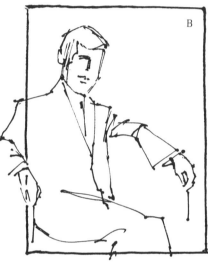

Figure 124. *When the head is positioned so it faces in, it can be balanced with a vignette around the profile on the inside.*

Figure 125. *(A) Hands are part of a triangle that comprises the three-quarter view portrait. This triangle can be positioned so that it becomes an abstract balancing unit to the concrete form—the figure. (B) The paper's boundaries are confining. If a pose spreads more than you anticipate, don't force the figure on it so that a hand is cut off as it is here. It's better to turn the sheet lengthwise or reset the pose.*

chapters. The whole unit should not seem to be weighty on one side or in one corner. If one of the group happens to be an adult and the rest are children, the adult, as a larger mass, can counterbalance all the other children.

Flattery

The question of flattery always comes to mind when you have a commission to draw a portrait. Flattery is simply drawing people as they like to see themselves or as they would like to be seen. Slight defects or irregularities are usually accompanied by pleasing and interesting aspects of the face, and the artist could choose to emphasize the latter. However, too extreme a deviation from the realistic representation of your sitter becomes a caricature. Just remember that flattery should not be a conscious effort to make your art a saleable product and that drawing your instinctive and honest response to your sitter contributes to your growth as an artist.

Figure 126. *If the hands aren't to be included and the rest of the body is just a large area, a vignette pattern can be used at the bottom. The pattern's "busyness" will balance the head.*

6.
Positioning the Head and Hands

Positioning the head of a sitter is more a matter of what you *don't* do than anything else. When a person sits for a portrait, he wants to present the best possible image of himself. It should be one of dignity and openness, and should display the best features or characteristics of the sitter. The artist may discover a pleasing feature that the sitter himself isn't aware of, since many times people have mistaken ideas about how they appear to others. Also, don't forget that you have to consider the people who are going to look at the portrait. If the pose is strained, it will be a strain to look at, so it doesn't serve any purpose to try a clever or unusual pose.

The head, in most cases, should be posed nearly straight, although you may tilt it if this is a particular mannerism of the sitter. Youngsters sit this way sometimes (Figure 127). Tilting the head can give expression to the head or be a giveaway as to the type of person the sitter is. A slight tilt to one side, for example, might show a person to be inquisitive about life (see Figure 128). If the head tilts back in a natural way (Figure 129), it implies that the sitter is a self-confident person or one of regal bearing. If the sitter has a slight frown, as in this pose, his expression could come across as an Olympian fierceness. Just the opposite is true of a pose in which the head hangs down, with the eyes looking up from under the brows. This isn't the human dignity you're looking for, and so if possible, have the sitter refrain from this downcast attitude.

To make the drawing more interesting, you might try a slight turn in the pose so that there won't be too even a distribution of the facial features. Also, if the sitter has a pleasing profile but he wants a front-view portrait, a three-quarter view incorporates both (see Figure 130). If one or the other views is more pleasant, you can work from whichever is best. Usually, an uptilt of the nose keeps it from looking too long, especially when you're trying to keep women and children from looking too old. Also, the eyes are easier to draw and look more natural when the head is tilted slightly back.

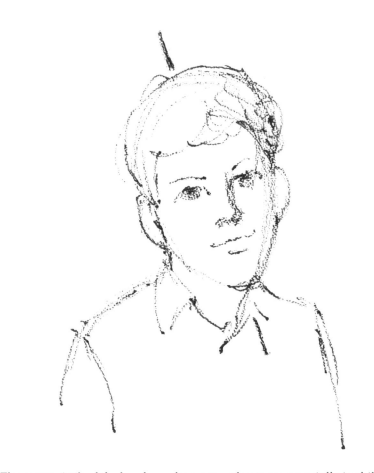

Figure 127. *A tilt of the head may be a natural gesture, especially in children.*

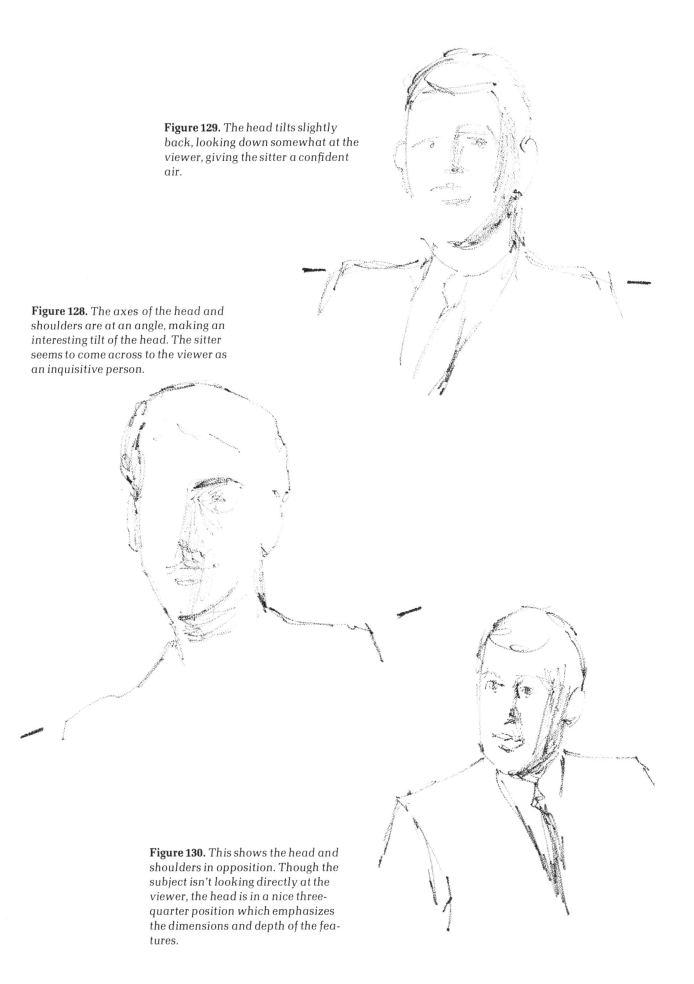

Figure 129. *The head tilts slightly back, looking down somewhat at the viewer, giving the sitter a confident air.*

Figure 128. *The axes of the head and shoulders are at an angle, making an interesting tilt of the head. The sitter seems to come across to the viewer as an inquisitive person.*

Figure 130. *This shows the head and shoulders in opposition. Though the subject isn't looking directly at the viewer, the head is in a nice three-quarter position which emphasizes the dimensions and depth of the features.*

Relationship of Head and Body

When I'm setting up a portrait, I'm inclined to pose the head and body in opposite directions, as in Figures 128, 129, and 130. In Figure 131, the sitter faces straight ahead with her body in profile, giving a nice, graceful curve to her neck. Figure 132 is also a side pose of the body, but because the arms hang and the head is turned slightly, it isn't as tensed as the other. This three-quarter view of the head could be better for some sitters. Here also, the head tilts back a bit and this, plus a curve of the spine, forms a pleasant S curve in the figure. Both of these last two poses are hard for a sitter to hold, so you'll have to keep reminding him to return to it. Another pose that solves the problem of fitting hands and arms on a small canvas is shown in Figure 133. In a slightly different pose, you could also have the sitter's hand slanting away from the viewer (see Figure 134).

Figure 131. *An extreme swing of the figure away from the head axis, raising the arms and permitting the hands to be posed on a short paper.*

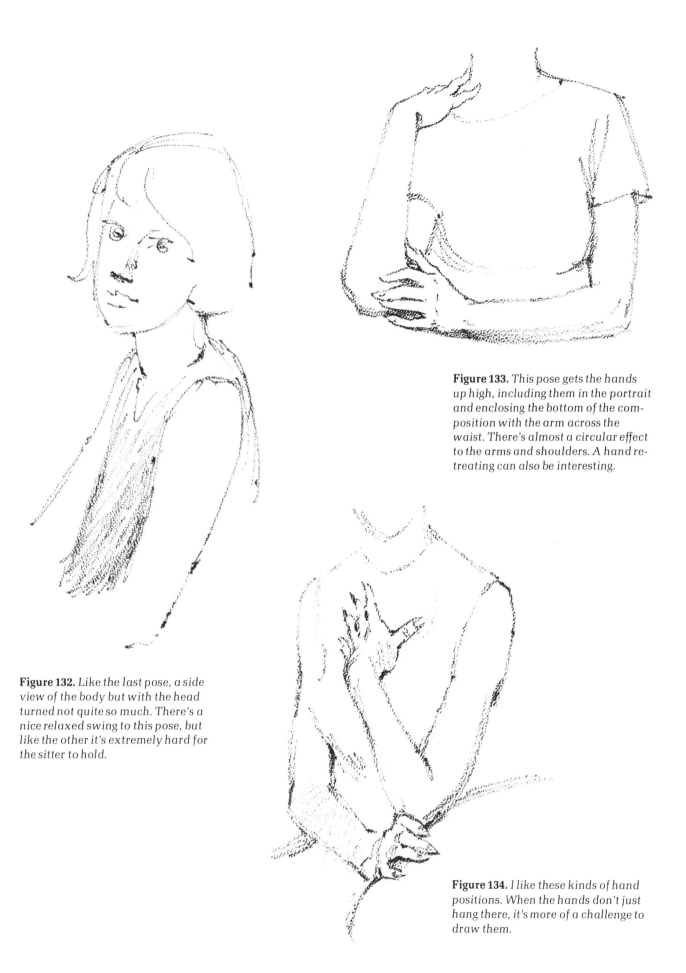

Figure 133. *This pose gets the hands up high, including them in the portrait and enclosing the bottom of the composition with the arm across the waist. There's almost a circular effect to the arms and shoulders. A hand retreating can also be interesting.*

Figure 132. *Like the last pose, a side view of the body but with the head turned not quite so much. There's a nice relaxed swing to this pose, but like the other it's extremely hard for the sitter to hold.*

Figure 134. *I like these kinds of hand positions. When the hands don't just hang there, it's more of a challenge to draw them.*

Posing the Hands

In contrast to what little variety there is in head poses, the hands and arms can be placed anywhere in a seemingly infinite variety of positions. The problem is that they look awkward much of the time and you're liable to try to make them do more than they're capable of. In spite of their mobility, hands can still look stiff and tense. You should try to get some interest in the flow of the arms by changing their direction at the joints, like the bend of the wrist (especially in women's hands.) Try to get some variety in the spacing of fingers. (Figure 135); they shouldn't look like a row of piano keys. If a man feels awkward with his hands, then give him something to hold. Figure 136 is one idea, and it also solves the glasses problem.

An arm resting on a chair with the hand hanging is a common pose—and nearly always uninteresting. The arm itself, if bare, doesn't do anything, and the foreshortened part is very dull. The body can be repositioned so that the arm can do something else. If you have to throw in a pillow or some kind of prop, do so. It will force the arm and hand into new or novel angles. I read somewhere that having a hand up near or on the face was contrived, but I don't agree. In a casual pose, people often do something like this, and besides it's a great way to have one hand doing something else (see Figure 138). Bringing the hands together is always a good solution for both arms and hands. The arms seem to be more a part of the body, leading the eye to the hands, where various things can be done with them together (see Figures 137 and 139). Just be sure that one hand is posed in variation to the other. Interlacing the fingers works well as long as they don't appear too uniform.

As with the hand touching the face, a hand resting on the shoulder or holding a pillow are natural gestures. If you watch your sitters during your interviews—when they're not aware of it—for example, they'll find a natural easy pose and this can often be your solution. I go through the business of trying to find a pose sometimes for half an hour. Then I give up and tell my sitter to relax, while I do something else, like mixing paint. I watch them out of the corner of my eye, and sure enough, they fall into an easy, natural pose. Sitters try too hard to please and often don't realize that what seems good to them doesn't look right from our position.

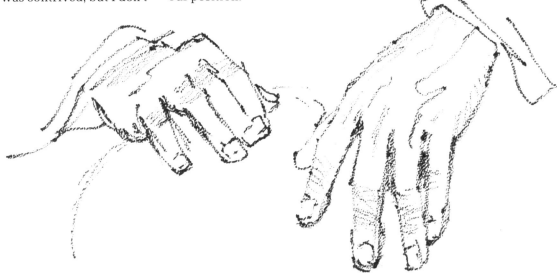

Figure 135. *A man's hands can look rather stiff, but if you randomly separate the fingers his hands will look more relaxed.*

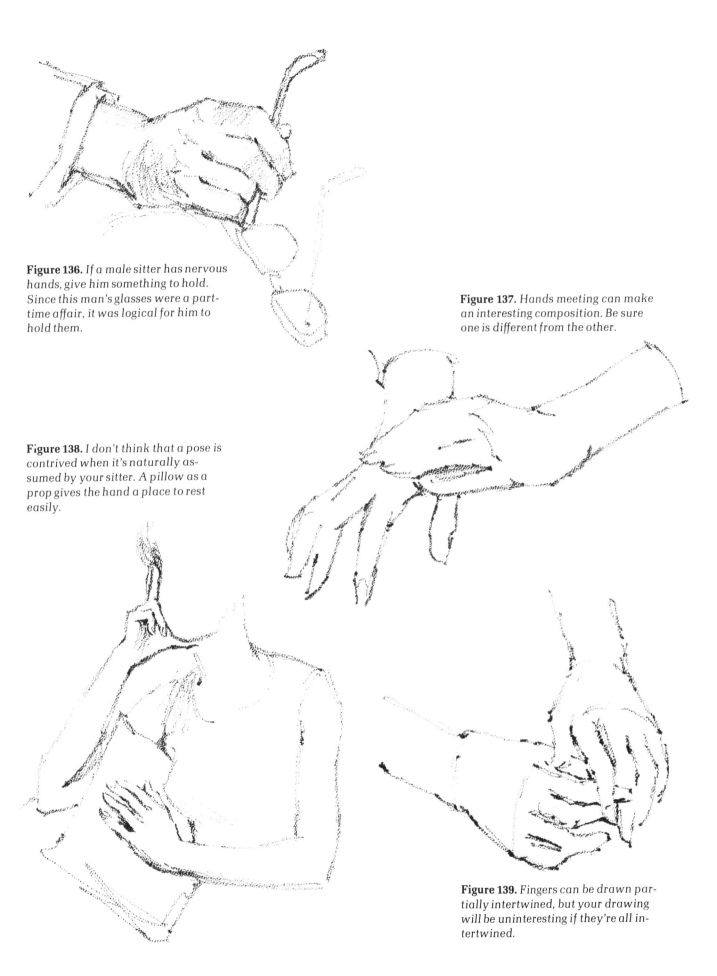

Figure 136. *If a male sitter has nervous hands, give him something to hold. Since this man's glasses were a part-time affair, it was logical for him to hold them.*

Figure 137. *Hands meeting can make an interesting composition. Be sure one is different from the other.*

Figure 138. *I don't think that a pose is contrived when it's naturally assumed by your sitter. A pillow as a prop gives the hand a place to rest easily.*

Figure 139. *Fingers can be drawn partially intertwined, but your drawing will be uninteresting if they're all intertwined.*

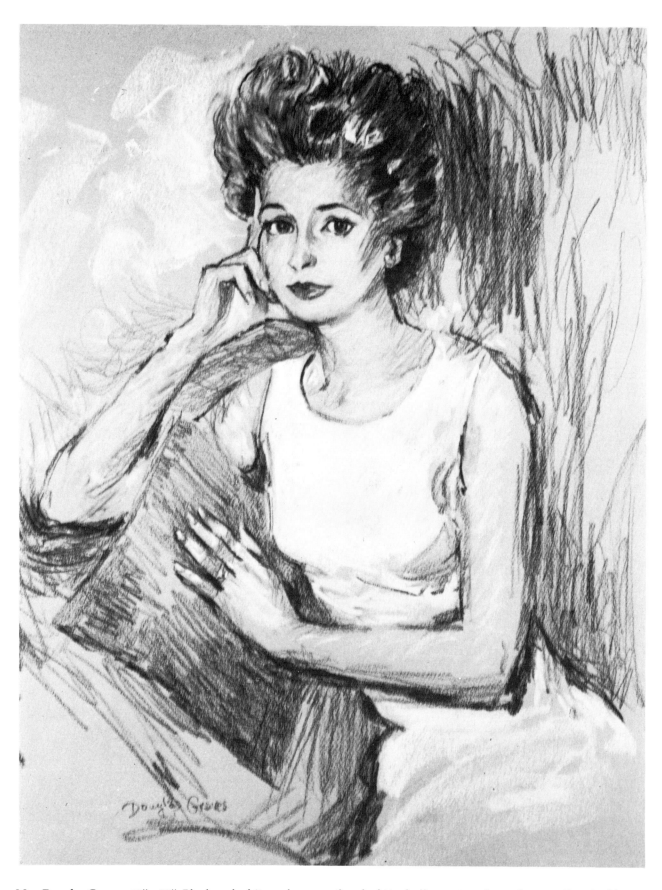

Mrs. Douglas Graves. *16″ x 20″. Black and white carbon pencil and white chalk on a toned pastel paper. Sketched from an earlier oil portrait.*

DEMONSTRATIONS

7.
Drawing a Plaster Cast of the Head

Before we get into rendering the individual parts of the face, I think it would be a good idea to get a feel for the whole head by drawing a plaster cast of it. I realize that when you've set out to do portraits you want a live body to start with, but be patient. Portraiture is basically just a very accurate drawing of a subject, so practicing with a plaster cast will serve to improve your eye just the same as drawing from life. Before you worry about establishing some emotional rapport with your sitters, you *have* to develop a good eye for their physical characteristic and be able to translate them into tone and line.

The advantages of starting with a plaster cast are that you can be sure it won't move and that it eliminates any consideration of color. It will enable you to concentrate on seeing things in gray tones. See the graduated tonal scale in Figure 140. Whatever vast ranges of tone that you may think you see, you'll probably find that it's difficult to shade any more than these 9 or 10 tones and still have an appreciable difference between them. In the projects that follow I will refer to the various tones by their numbers designated on this graduated scale.

The plaster cast used in this project is of the Greek goddess, Artemis, sometimes called Diane of Versailles. She has a classic face, with a hint of expression, and looks somewhat sad in certain lights. If you don't have a cast, try making a drawing of this one. If you do buy one, you'll find that these wonderful training objects are reasonably inexpensive; they also provide an *objet d'art* for your studio.

Once you've made a stroke on paper with a direct medium like graphite or carbon pencils, it's hard to change your mind too much without losing the freshness and spontaneity of your drawing. For this reason, your initiation to drawing figures should be with erasable vine charcoal. This will give you much greater freedom to manipulate the drawing—you can smudge, erase, smear, and literally push the drawing around to your heart's content. (Since I'm sort of reckless myself, in my drawing, I need something I can shove around.)

These demonstrations are all done with vine charcoal, the first on Canson Ingres and the second on D'Arches Ingres charcoal paper.

| | 1 | 2 | 3 | 4 | 5 | 6 | 7 | |

Figure 140. *Here are the seven tones that fall between white (left) and black (right). The human eye is supposed to be able to distinguish the difference in tones up to about a range of ten. Since the charcoal tones are somewhat mottled it would be hard to see more than I have here. Notice how the edges nearest the neighboring darker square appears lighter. This is a double-contrast force: not only do you visually react to the contrast between the squares but also to the contrast within the patch itself.*

Front View

1. Here I start with a slashy, smeary outline. The head is whitish in color, with the light coming from the left providing good contrast, and with a hint of toned drape in back.

After you've drawn everything roughly, it's easy to see the errors. Now I see that the head is too short, the crown doesn't arch enough, and the mouth and chin area is too delicately drawn. I add tones that unflatten the forehead and the sides of the face, bring out the nose with a well-defined shadow, and redefine the mouth.

2. Now, I concentrate on the subtle tones that shape the eyes and the surrounding bone structure. Because you're accustomed to seeing people in a multitude of values (not only related to light but to the pigmentation of their lashes, pupils, irises, etc.), you will probably find it difficult and confining to draw plaster eyes in just light tints. I conclude Step 2 by developing the coiffure and ears.

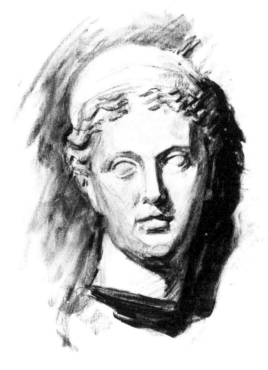

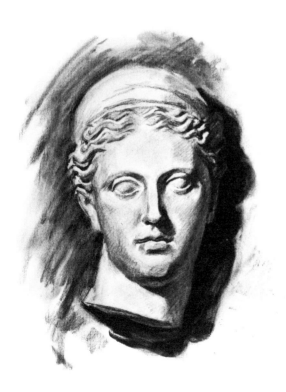

3. The final step is to go through the *whole* drawing, developing a sequence of highlight, halftone, shadow, and reflected light. (This last factor is actually a result of strengthening what is known as the "core," the very dark value that occurs as the form turns into shadow.) Notice that the photoflood light causes the shadow of the plaster cast to be soft-edged, especially around the hair, making it look like human hair.

Three-Quarter View

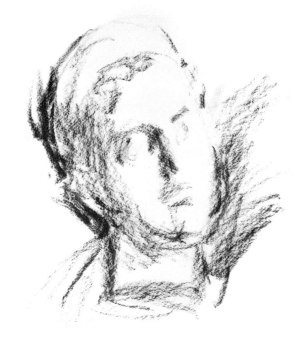

1. I position the cast higher this time, and with a drape angled behind it; then I shine my light directly on the face. This position and lighting best conveys the figure's rounded shape and plaster surface. Starting with a series of loose, wide strokes, I roughly outline the plaster cast.

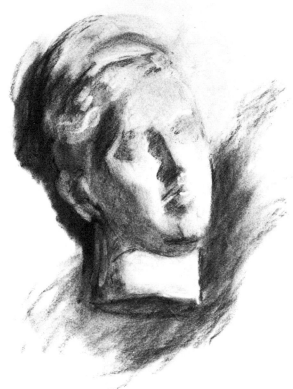

2. Next, I use a technique that oil painters call "scumble," which is a soft, hazy blending of the medium. If you manipulate the material this way, you'll very quickly see a form developing right out of your drawing.

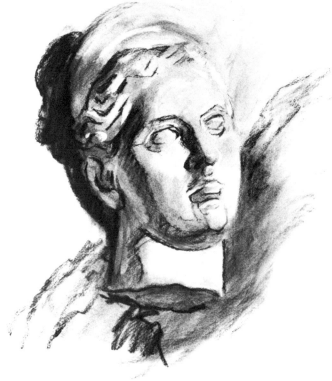

3. Now I have a clear indication of form and a general tone pattern (including the high key and low key). I can easily block in exact shapes either by delineation or tonal gradations. Looking at my drawing, you get a strong feeling of white plaster bathed in a merciless light.

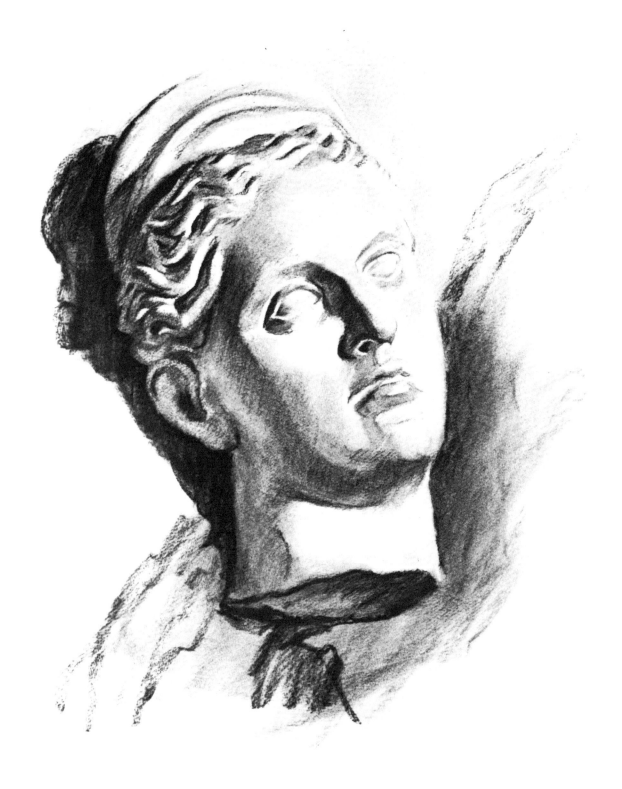

4. The final stage is to eliminate most of the tonal guidelines by absorbing them into the shading. You can do this either by slowly zig-zagging a hard charcoal stick over the various tones or by lightly blending the tones with a foam puff. Bright highlights can be lifted with your kneaded eraser rolled to a point. (As soon as it's dirty, be sure to knead it to a point again.) Notice that the light reflecting from the wall seems to cause an inconsistency in shadows of the nose and side of the face. It looks as though she had a left eyebrow but that tone is really the undercut of the brow structure.

8. Drawing the Eye

In Chapter 2 I discussed the anatomy of the separate features. Now I want to consider a larger viewpoint, that is, drawing the parts with more consideration for the total surroundings and less attention to detail. The more you add parts—eyes, nose, mouth—to the whole face, the more you can generalize. Even though much detail is left out, the general structure is correct.

Notice that in rendering these steps I try to use tone rather than line. In a smudgy way, I attempt to convey the depth of the eye in the socket, the roundness of the lid, and the dark presence of the pupil. To suggest sparkling eyes, try a black carbon pencil on middle-tone gray pastel paper. First, I use the black to rough in the eye. Next, I use white pencil to develop the planes further and to establish the whiteness of the cornea. I also indicate which will be the lightest areas (such as the corner of the eyelid) and which the darkest (in this case, the pupil). In the final stage, I strengthen the values, darker or lighter, then add details and highlights.

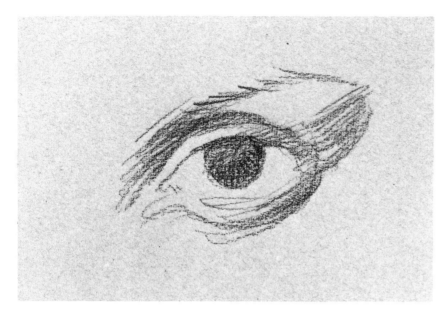

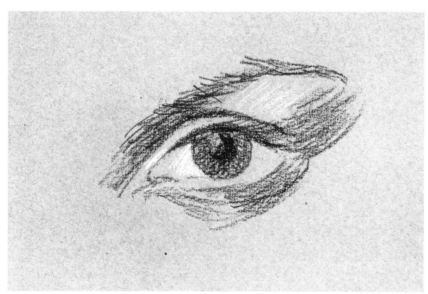

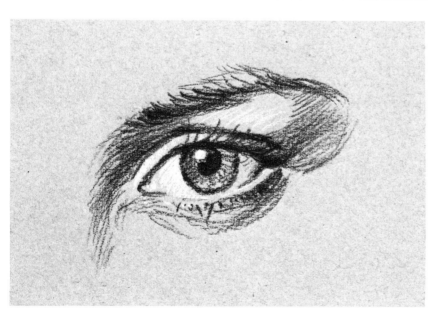

Front View

1. Using a B pencil, I start the eye by smudging in a round, darkish cornea, around which I'll build the rest of the structure. The upper lid rests right on the cornea, actually covering about a quarter of it. The lower lid is molded in a deep curve, forming the boundary between the eye and cheek. Both of these lids are shaded to suggest the circularity of the eyeball underneath. The orbit of the eye is also shaded near the bridge of the nose and at the outer eye corner. A few quick lines show where the eyebrow will lie.

2. First, I establish the tonal spectrum—using the darkest black in the pupil and white pencil in the cornea. Next, I correct some of the eye proportions. I raise the arch of the upper lid so that it just touches the outer limit of the pupil, which is about half the area of the whole cornea. An attentive, alert eye will have this arching shape. Also, I close in the lower lid around the cornea and shade in the eyebrows.

3. I use the tones of my spectrum to further define the eye. On the left side of the cornea, I use white pencil to emphasize the roundness of the eye. I leave the right side the natural gray color of the paper, but also deeply shadow the upper edge and outer corners of the lower lids. I heavily shade in the crease above the upper lid and add lashes to both lids. The upper lashes are long, outward-sweeping lines, and the lower ones are short dashes. I darken the eyebrow and shade along the nose and around the outer corner of the eye socket. Last, I add a little white to the tear duct and specks of moisture on the edge of the lower eyelid.

Three-Quarter View

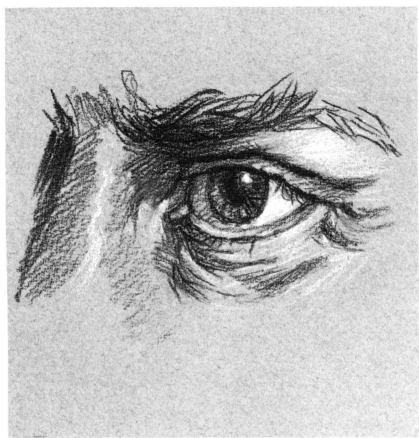

1. As before, I start by drawing the cornea and then sketch the lids and a suggestion of the nose. I indicate the basic tone of the eyebrow and position it close to the eyes to give a masculine appearance.

2. I establish the extreme lights and darks, using white pencil and pressing harder with the black one. I accentuate the eliptical shape of the cornea and pupil and then sketch in straggly eyebrows, laugh lines in the corner, and wrinkles under the eye. Remember, this is the testing stage; if any element doesn't work well, it can be erased since it's so lightly sketched.

3. In this step, I just add emphasis to what I've already drawn. I strengthen the gray and white tones along the front of the nose, in the eye corner, under the brow, in the sagging skin below the eye, and on the eyeball. Note that it doesn't take very much white shading for it to be effective; I add just a few scratches here and there in the corner and around the lower lid. The strongest areas of white are at the outer edge of the eye orbit and on the cornea. I make the eyebrow even more scraggly looking with a few well-placed lines, and leave the lashes sparse, with just a few at the top and bottom.

Profile View

1. The procedure is almost the same as for the front and three-quarter views, but since this is a profile, I have roughly outlined the brow, eyeball, and nose. This will also be a man's eye.

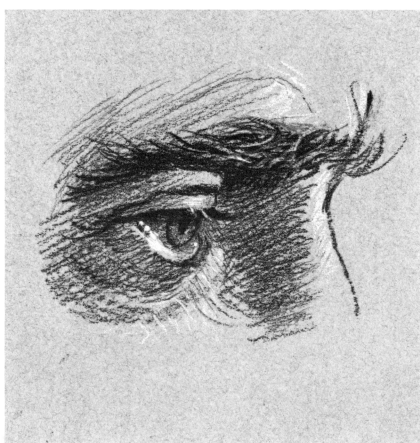

2. Now I add tone to my sketch. Most of the structure around the eye is in shadow, especially the inner corner of the eye orbit. I darken the crease of the upper lid and rim the eye with lashes. Again, I use white pencil to add some fine wrinkles to the forehead, moisture to the lower lid, and shine to the nose. I draw wispy hairs into each eyebrow.

3. Because this is a profile view, the shadows are much darker, and so I shade it very heavily. On the side of the nose, I shade around the form, giving it an illusion of smoothness. However, the skin under the eye looks more wrinkled if I shade at an angle to the form.

I blacken the brow hairs and try to sketch as great a variety of hairs as possible: long, short, straight, and curly. Then I use the white pencil to turn some of the black hairs gray. The eyelashes are both black and light gray, with the lighter ones resulting from the peculiar lighting situation. I also use the white pencil to show drops of moisture in the nearest corner of the eye. The cornea is not at all white here; since it's so much in shadow, I actually shade the cornea with black pencil. Remember that such shadows happen often, and darken, rather than lighten, the eyeball accordingly.

9. Drawing the Nose

In Chapter 2 I pointed out that although the nose is a simple structure, it's often drawn incorrectly. Usually the nose seems too long, too large, or too wide. Some important things to notice while drawing the nose are the shape and size of the bone structure, the shadows at the sides of the nose, and the relation of the nose to the cheeks and brow. You should remember to shade the nose in values similar to the rest of the face. Always keep the nose itself in perspective, with the nostrils appearing from underneath the nose projection, rather than seeming to be black holes in a flat surface.

The demonstrations in this project are done with graphite pencil, under various lighting conditions.

Front View

1. To start out I use a hard pencil, like a 5H, to indicate the edge of the nose as it falls into shadow and lightly outline the underside and the nostrils. I draw these lines softly—with the side of the pencil point—so that it doesn't dig into the board. That way, it's easier to erase if you make a mistake.

2. With light, diagonal strokes of a 2H pencil, I indicate where the shadows fall along the sides and front plane of the nose, under the tip, and on the cheek and upper lip. Then, with a B pencil, I go over the darker shadow at the edge of the nose. I use a 5B pencil to darken the nostrils; notice that the bridge of the nose and the nostrils set the high and low tonal keys.

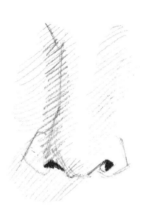

3. I go over the whole nose with a 2B pencil, deepening all the shadows, especially those at the bridge, around the wing on the left, and under the tip. Then, I just lightly shade the wing on the right side. The diagonal strokes used in Step 2 are rather formal and orderly but going over them now, makes them less so. This is all right, but you can't do it too much or your drawing will look messy.

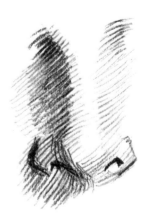

Three-Quarter View

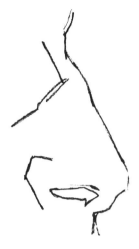

1. This is a three-quarter view which is lit from the front and from below. Once again, I start with a hard pencil outline, indicating the wing, nostril, and a shadow at the bridge.

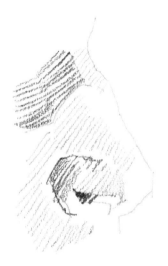

2. I use a 2H pencil for the lighter shadows at the side of the nose and cheek. With a 2B pencil, I shade the darker areas along the wing and bridge of the nose. The darkest value will be the shadow within the nostril.

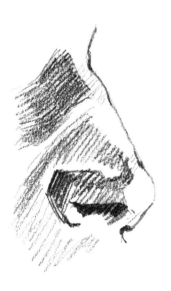

3. With a 4B pencil I darken the values of the nose and indicate its several planes. Notice that the shading here is quite angular, especially around the wing area. Again keeping the nose in perspective, I shade in the nostril so that it appears partly hidden by the side wing. I soften this black shadow slightly on the lower edge of the nostril. The dark shadow on the side of the nose is offset by the light reflected on the ridge of the nose and the cartilage tip.

Profile View

1. I use a 5H pencil to make a basic outline of the nose and to indicate the placement of the nostril.

2. I begin shading with a 2H pencil. To add dimension to the profile, I sketch in some light lines parallel to the ridge of the nose, and shade around the nostril and tip. Here, I indicate the cheek very simply with a few curving lines.

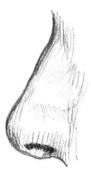

3. To give the nose further shape and texture, I use a 2B pencil to shade the wings, darken the nostril, and re-emphasize the ridge contour. Finally, I use the 2H pencil to add subtle changes of value along the cheek.

10.
Drawing
the Mouth

The mobility of the mouth depends on the muscles and tissues that comprise it, so that any drawing of the mouth should convey their presence. You'll find that drawing the mouth in repose and drawing the mouth smiling involve very different considerations. However, in most portraits the mouth is closed and serious, so in these demonstrations I'll draw closed mouths with pleasant expressions.

These sketches are done on a darker-than-middle-tone pastel paper with black and white carbon pencils. The procedure for rendering them is to sketch in the general jawline (a continuation of the head oval), and then rough in the lips. With light pencil strokes, I draw the circular area around the mouth that extends up to the nose and down to where the chin starts to jut out. After you establish the shape of the lips, you can work on the surrounding sublteties—wrinkles, shadows, creases, and hair. In a woman's portrait, these elements are very elusive and apt to age the face if not judiciously handled. Paradoxically, for a man they are considered "character builders." In either case, they must be correctly drawn, so study the facial anatomy in this region carefully.

Front View

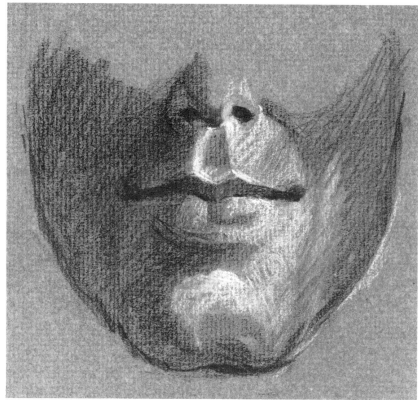

1. I quickly sketch the jawline, the circular mouth area, the upper lip, and the chin. A slight indentation in the chin indicates the cleft.

2. Using white pencil, I locate the areas that catch the light: the top of the chin, the ridges beneath the septum of the nose, and the top of the upper lip. To add dimension, I shade in the sides of the face, and darken the shadows cast by the lips.

3. In this step, I do most of the subtle molding of the face, especially around the lips. I use white pencil to bring out the light plane running from cheek to chin, and the subtle crease extending from the corner of the mouth down the side of the chin. The shadow on the left of the mouth is quite dark up near the nose and lighter near the lips, projecting the mouth outward. The shadow under the lips curls around the chin to meet the shadow in the cleft. The separating line between the lips is sharp and dark, indented in the center, and is visible right into the corners. The lower lip is rendered with very soft shades of both black and white to convey its firm, rounded structure. (Refer to Chapter 2 for details on construction of the mouth.) Notice that the lower edge of the lower lip is rather indistinct and that the extreme corners of the upper lip curve *slightly* upward, giving the mouth a happy countenance. As a finishing touch, I bring the lower part of the nose into focus by adding a highlight to the right of the nose and shadow to the left.

1. Here I quickly sketch the rough outline of a fuller mouth—jawline, lips, and nose. With two light lines I indicate where the highlights will fall around the lips and chin. You'll notice that these lips are wider than those in the previous demonstration and that the upper lip is quite as large as the lower.

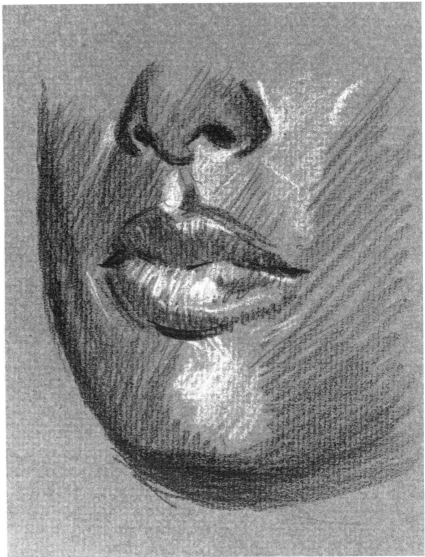

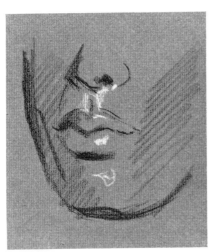

2. I don't add too many specifics here but rather just some guides for what I will draw later. I use white pencil to highlight the ridges below the septum and also the lips and chin; these highlights establish the lightest value of the tonal spectrum used in this sketch. Then, using medium values of the tonal spectrum, I roughly shade in the side planes of the face.

3. Here I develop and emphasize the angularity of the face with a dark plane slanting along the left side of the jaw, and a middle-tone area indicating the right side of the jaw. Also, notice how I shade the mouth area to make it angle out from the nose. On the left, I darken around and below the nose wing with slanting, black strokes. On the right, I use white pencil to lighten around the nose wing and bring forward the area above the lip. I work the shading and high-lights across the lips to give them realistic texture.

Profile View

1. There are two things to aim for in a profile of the mouth. One is that each feature recedes slightly beneath the other, nose, mouth, and chin. The other is a general tonal pattern demonstrated here: shadow under the nose, light above the upper lip, shadow on the upper lip, light on the lower lip, shadow under the lips, light on the top of the chin, and finally, shadow underneath the chin.

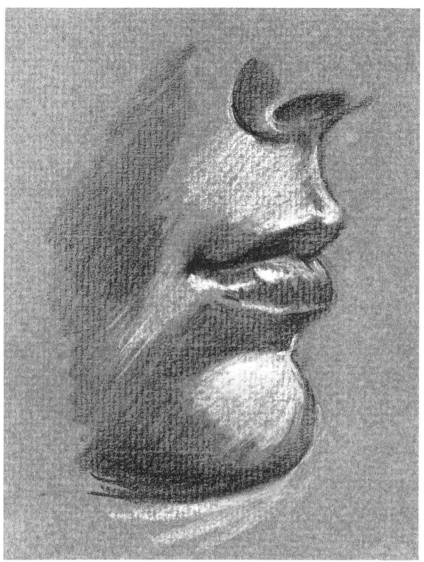

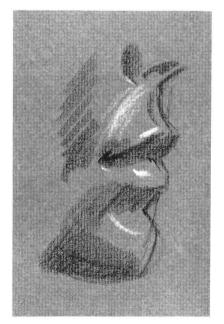

2. Here I mark the highlights and lighter-toned areas with white pencil. I indicate the darker shades along the cheek and underneath the chin, and accent the corner of the mouth.

3. If you have sketched a well-proportioned chin and established an accurate tonal structure, you will find this last step the most fun, since here the drawing comes to life quickly. I add halftones to bring the face into focus and give it dimension, and then carefully stroke in texture on the lips. I especially enjoy developing the white highlights, as they seem to give the face expression.

11. Drawing the Ear

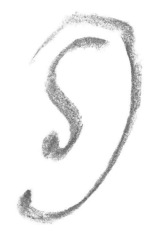

Front View

1. For the front view, I draw somewhat flattened C and S shapes. Notice that the bottom of the S is small and angular while the top is curved, and that the top of the C breaks slightly in back.

When drawing the head, you'll soon realize that the ears don't present as much of a problem as other features, since usually only one full ear, part of one, or portions of both are visible. I guess it's just as well that two complete ears rarely show, because I don't think they add to anyone's beauty. I must say, though, that I find ears very interesting objects to draw because of the crazy shapes they contain. Remember, as with any part of the body that shows in a portrait, if you slough it off—draw it with obvious lack of knowledge—you ruin the whole portrait. Make sure you dig in and learn what fundamental shapes comprise the ear and then observe them carefully on your subject.

For these demonstrations, I work with gray chalks on smooth layout paper. Gray chalk is a good medium for the broad handling of a subject and this is also a good opportunity to become familiar with the gray tonal scale (see Figure 140). Here, I visualize the ear using the method that I discussed in Chapter 2. It may not seem particularly artistic, but I'm sure this method will establish the construction of the ear rather firmly in your mind. Later, you probably won't need this little trick.

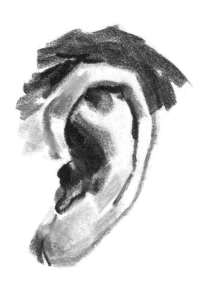

2. Now I add tones for light and shadow. I use a No. 3 chalk to outline the side of the face in front of the ear, and around the outer edge of the ear. I darken the hair and concha with a No. 6 chalk and then switch to a darker chalk, No. 7, to shadow underneath the curled top edge of the ear.

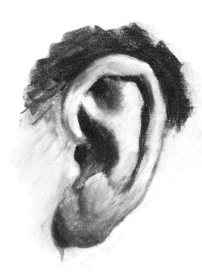

3. I fill in the whole drawing with gray values, eliminating all evidence of the white paper. If I need highlights, I add white chalk. Somehow it's disturbing to leave the white paper showing through in a rendering of this kind. Mainly, in this step I try to give a more realistic shape to the parts of the ear, especially the flaps and the lobe. You will find that the tones of the ear are generally darker than in the face and that there is also a slight shine to the cartilaginous tissue of the ear.

Side View

1. This time, I start with the side view because it best illustrates the basic C and S shapes of the ear. Using a No. 3 gray chalk, I draw these two letters. (Remember the C and S are always reversed in relation to each other.)

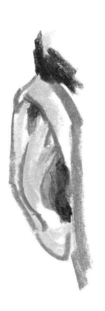

2. I block in the forms over the basic outline. I use a No. 3 gray on the curled edge of the ear and on the lobe. Notice that the gray gets lighter on the part of the ear nearest the light source, which is behind the ear. I deepen the ear hole and concha with black and dark grays, and indicate the division of the U-shaped antihelix as it disappears under the upper edge (helix). I draw in hair surrounding the upper part of the ear.

3. Now to develop the linear sketch into a more tonal drawing, I soften the heavy lines and carefully model all the forms, using No. 2 and No. 3 grays plus white for highlights. (The dark areas are all done in values of 6 and 7.) By manipulating edges you can give the ear dimension: a hard edge brings the rim up in front of the antihelix; a soft edge rolls the antihelix into the concha.

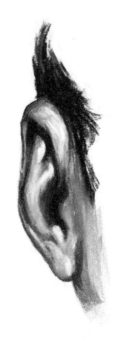

12.
Drawing the Hair

When you first draw hair, you'll probably find it tempting to delineate each shaft. Don't. Try to visualize hair as a composite, rather than as thousands of individual hairs. A general softness should be the rule in most renderings of hair, although this is subject to the medium you're using. For example, you'll find that with charcoal or chalk, a tonal kind of drawing seems natural, with the emphasis on the arrangement of light and dark tones. However, if you try to develop tonal patterns with pencil, you'll quickly see that your pencil strokes result in hard, thin, outline-y edges. This makes it look like each hair has been drawn individually, when actually each pencil stroke should represent several strands of hair.

The hairstyle is comprised of many distinct segments, each having its own light pattern, and yet each falling into the overall tonal plan. This overall plan can be likened to a checkerboard arrangement; two adjacent sections of hair will have alternate shadows and highlights, and these will be out of step with neighboring sections of hair.

You should also try to achieve contrast within the over-all tonal concept. One large area of hair can have a "hot" highlight—even dark hair—while the other light and shadow areas are more subdued.

You'll probably have extreme darks, too, invariably occurring around the ears if they're visible.

To interpret hair color in terms of black and white, you generally draw brunette hair in black tones, brown and red hair in middle tones, and blond and gray hair in very light tones. However, you'll also find that the lighter hair colors still have a broad range of tones, often with dark, almost black, values around the neck and ears. Depending on how strong the light is, a brunette might have a bright highlight on the hair, but probably will not display as great a spread of values as a blond.

Hair shouldn't be made to look like a shiny metal cap. No matter how well combed, some strands of hair will separate and divide, sometimes in very large sections. The ends of long hair wisp and crisscross, giving a soft appearance. Generally, short or shingled hair lies smoothly all around, has a lighter, even tone, and the ends don't seem to frizz. Edges of hair around the face should blend softly into the flesh on both men and women. A part should barely be suggested and be slightly uneven. Sometimes strands of hair fall down onto the forehead or across the ears.

The three demonstrations that follow are of brunette hair, blond hair, and an Afro hairdo.

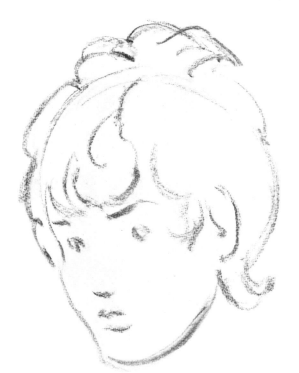

Brunette

1. In a case where the hairdo isn't apt to follow the contour of the head, it's a good idea to rough in the approximate top of the head. Here I use vine charcoal to outline the head and face.

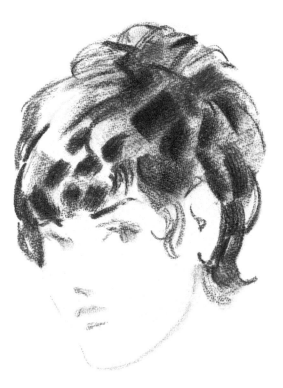

2. With broad sweeps of the side of the charcoal, I shade the hair in values ranging from middle tones to black. Notice that my shading is deliberately "open"—this is to preserve the lighting effect and to keep the design of the hair intact. (The hair is a "design" in that the small dark patches in front offset the larger areas of black toward the back of the head.) Again, notice that the shiny hair texture is achieved with a checkerboard array of black patches and lights.

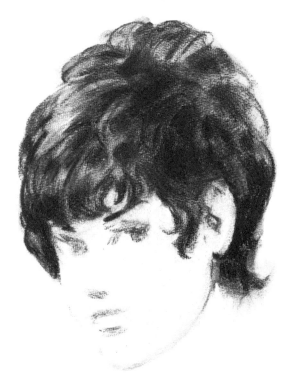

3. I carefully rub my dry finger over the whole head of hair to generally soften and subdue the tonal values. Then, using a heavy black, I darken the hair above and behind the ear. The wispy hair at the top appears to have light shining through it; this effect is achieved by drawing the hair in soft No. 4 values with various black strands arching over and through it. For variety, I lighten and soften the wisps down at the nape of the neck. I like charcoal for rendering hair, perhaps because it best expresses the softness and sheen with so little effort on my part.

Blond

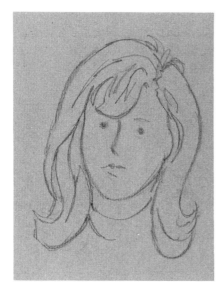

1. On dark paper, I sketch in the face and hair more carefully for you than I would for myself, because I want you to see how I develop the different tonal areas.

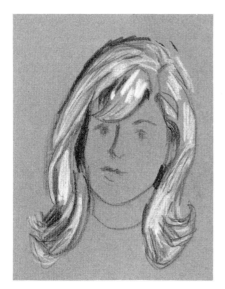

2. Here I broadly indicate what kind of tone will be in each area. I stress the extremes, like the darks around the face and ears, and the highlights in the front and sides of the hair. I outline the top of the head slightly, to separate the head from the background.

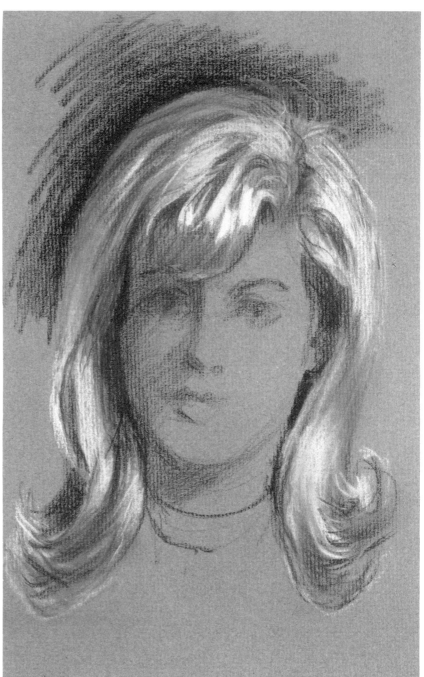

3. I blend the lights and darks where the hair is the smoothest—around the top left and lower right. I use wide, white strokes to highlight the front forelock; notice that I position these strokes somewhat unevenly across the forelock, setting them off with some quick dark strokes. I draw in a rather random part, almost lost from sight and only defined by its light and dark side. For variety and softness, I add a few light-tone lines—especially at the ends. You should remember that variation in values, texture, and softness are important, but always within the proper framework.

Afro

1. The Afro is so unique that it has no precedent as far as rendering hair. Since it's a very simple shape, little has to be done for a preliminary layout. Here I draw a quick outline.

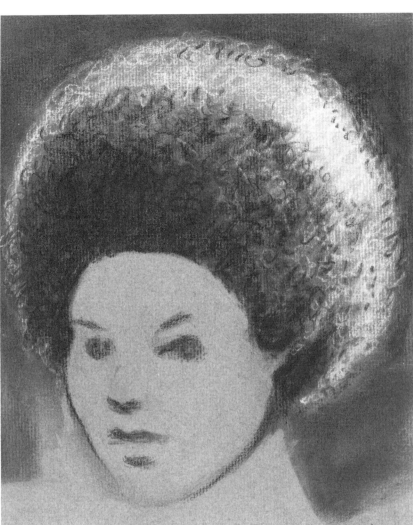

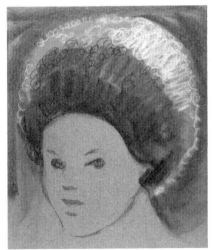

2. This view is lit from the rear, which not only gives the hair an interesting light and shadow pattern, but also demonstrates how fine and transparent the Afro can be. The hair isn't usually very black so I use a variety of tones, starting with a black edge around the face and ranging to white pencil in back.

3. The best way to render the Afro is with wiggly black and white lines. I smudge much of it, but leave enough to convey the curly texture. I add black specks into the smudgy white area to represent the dark background showing through the hair.

13.
Drawing the Torso and Arm with Drapery

Portraiture includes drawing the sitter's clothing, and to give your portrait a professional and accurate appearance, you should carefully study how drapery reacts to the body underneath. Drapery falls into predictable and recognizable folds, whether it's hanging free, draped over something, lying on a level surface, or covering the human figure. I'll only discuss the behavior of drapery in relation to our subject, the figure in portraiture.

How clothing behaves depends on where it falls on the person and also what tensions are applied to it. It doesn't make any difference what type of cloth you're dealing with—the same principles apply. In portraiture, there are five possible categories of behavior: (1) lying flat against, and clinging to, parts of the body while being pulled in tension folds across a prominent point (Figure 141); (2) crinkled or crushed in a corner, like in the crook of the arm or leg (Figure 142); (3) pulled or crushed along a tubular part of the body, such as the arm, leg, or torso (Figure 144); (4) falling in folds to another level (Figure 143); (5) gathered, falling straight down (Figure 145). If you want them to look convincing, folds should not be drawn randomly.

Clothes have different properties, such as color, pattern, weight, and texture. Color, of course, has to be interpreted in black and white. Strong colors, whether warm or cool, should be dark, while weak tints should be light values. You'll often have to draw patterns—stripes, for example. When rendering these, don't try to follow the contour of each fold; instead, angle across with a series of straight lines (see Figure 146). Notice carefully the direction of the stripes on the collar and cuffs. With floral patterns it isn't so important that you put in every detail or get the pattern precisely accurate, but be sure to have a consistent repetition over the whole garment. Heavy fabric, wool for example, has round, bulky curves; thin fabric, such as cotton, has crisper, more angular curves. Notice the difference in fabric weights in the two demonstrations that follow. To represent the different fabric textures, you'd probably use a monotone value scale with very little contrast for the duller fabrics, while for a fabric like a jersey, silk, or satin, you'd probably use a scale with a lot of contrast between lights and shadows. Figure 141 shows a shiny, satin-type fabric. Be careful to show the thickness of the material at such places as collar and sleeves.

The following demonstrations, showing how drapery acts in contact with parts of the body, are done with black and white carbon pencils on gray paper.

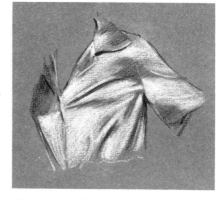

Figure 141. *The arm is lifted away from the body, pulling the blouse across the breasts and causing wrinkles to radiate from the button openings to the arm seam, and from this seam to the waist.*

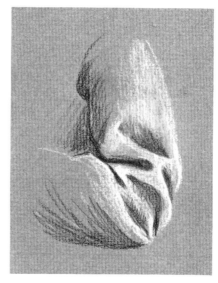

Figure 142. *Notice how this type of fold alternately enters the sleeve from side to side, often creating diamond-shaped depressions.*

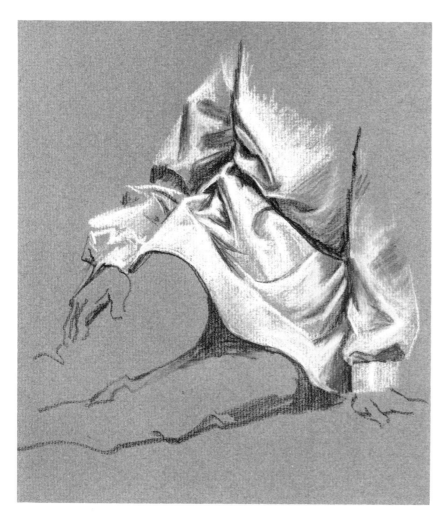

Figure 143. *(Left) This tunic is gathered by a belt. The cloth falls one way into a fold and then bends sharply into another fold in the opposite direction.*

Figure 144. *(Below) The folds of a gathered sleeve encircle the arm and should be of different lengths and change direction slightly.*

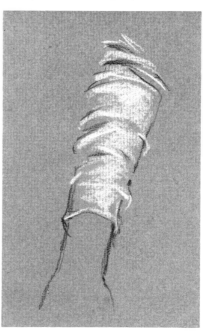

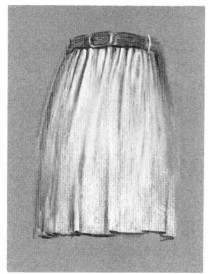

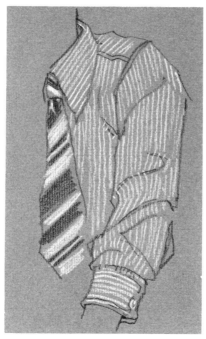

Figure 145. *(Far left) This skirt is gathered by the belt, with narrow folds billowing out slightly and forming consistent light and shadow patterns.*

Figure 146. *(Left) Stripes should be drawn quite straight but should angle sharply across the folds. If the fold is small enough, the change of direction in the stripe can be ignored. The stripe in the tie itself is briefly interrupted by the crease beneath the knot.*

Torso with Light Drapery

1. I sketch the outline of a woman in black and white pencil on gray paper, making the parts of the body that will be covered white.

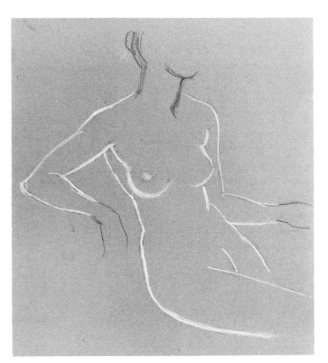

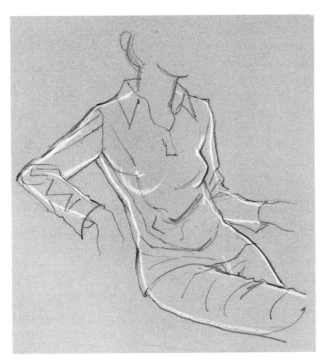

2. I sketch the contour of the fabric in black; notice that the black is heavier where the fabric contacts the body. The lighter black lines represent the different kinds of folds in her clothing. The material collapses into accordian folds at the elbows and around the waist. There are lines of stress between her right shoulder and elbow, although the shirt pulls somewhat less across the breast. The stress lines across her right hip combine with the telescoping effect of her pants leg.

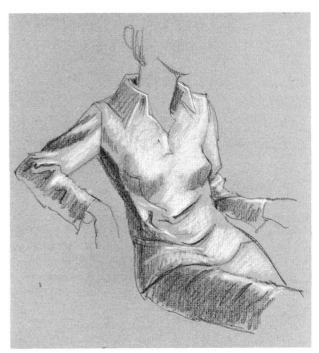

3. Here I introduce a light and shadow pattern which establishes the general shape of the garment. If the fabric is very thin and clings to the body, you're actually rendering the body shape and adding a few folds over it.

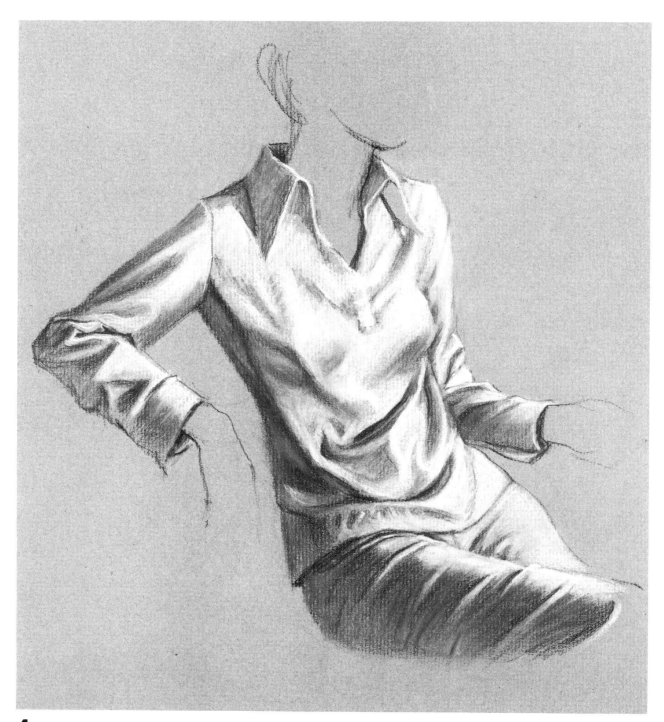

4. This is the fully rendered garment with all of the folds individually rendered as to highlight, halftone, and shadow. A few folds are highlighted, such as those slashing across the stomach and lower torso. The high contrast in this drawing indicates a shiny type of material. Though this material is somewhat soft, a crispness doesn't hurt the looks of it, such as at the crook of the arms. I indicate a certain thickness of material at the collar and cuffs. The fabric crinkling along the right arm forms a zigzag pattern because of action and counteraction; that is, as the fabric is pushed one way, there's resistance against it from the opposite direction. The crinkling around the leg is combined with a stretching of the material which cancels the zigzag pattern.

1

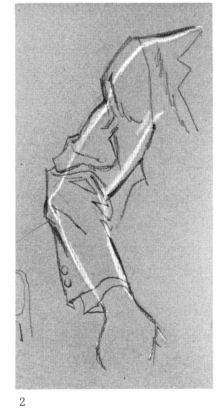

2

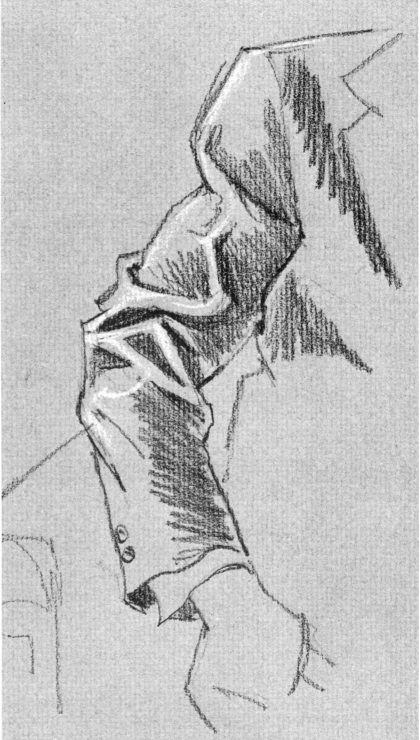

3

Arm with Dark Drapery

1. With a white carbon pencil, I sketch a man's arm resting on a chair arm.

2. I outline the shape of the fabric with a black line, making the areas that come in contact with his arm heavier. Since this is a thicker, heavier garment, the sleeves cling to the arm less; also, since the shoulders are padded, they bunch up away from the arm. There are points of stress at the shoulder and elbow, so that the coat sleeve is pulled up the arm. Notice how the wrinkles conflict along the upper arm, entering alternately from one side of the coat sleeve to the other and at times combining to form a diamond-shaped wrinkle.

3. Here I establish the total form in black shading. I use a bit of white to designate where the highlights will fall. I redefine the folds with shading.

4. I shade in and blend the shapes to convey a dark, wool-like fabric. The depths of the folds are very black and the side lighting doesn't require too many white pencil highlights. The folds are generally thick and are inclined to be slightly rounded for a heavy wool fabric. I try to suggest this thickness at the sleeve opening and in the protruding shirt sleeve. Details should be suggested, but not emphasized, such as the seam at the shoulder, the lapel stitching, and the buttons on the cuff.

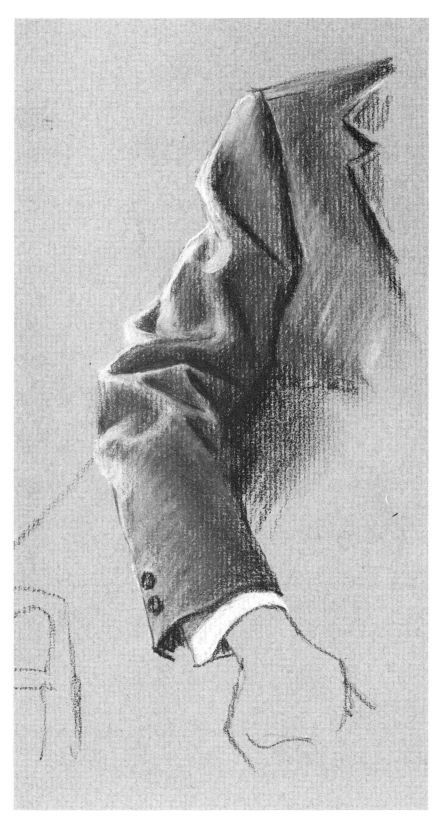

4

14.
Drawing
the Hand

One of the comments that I've often heard from people looking at a good figure drawing or portrait is how well the hands are done. Even people with no art training are quick to observe whether the hands are good or bad.

In Chapter 3 I tried to equip you with an understanding of the highly complex physical mechanism of the hand. Now I want to emphasize technique—how to render the hands in a few typical portrait positions. You can add your own inventiveness to the basics given here. You'll probably find that each pair of hands, which are as individual as faces, needs special attention to give the hands the expression you want.

Consider the relationship of the size of the hands to the rest of the figure. One of the most repugnant things to me are hands that look too small. Even if it's a drawing of a woman or child, the hands should be large enough to look capable of functioning. A basic measurement is to compare the hand with the face. The distance from the wrist to the tip of the middle finger should be equal to the distance from the chin to the top of the forehead. The hands should also look believable in the way they attach to the arm. This is

a very easy mistake if the arm has a long sleeve, especially in a man's jacket. Check the whole drawing of the arm, paying careful attention to its anatomy, where it attaches to the shoulder, and where the elbow is located. Such joints and angles will influence the location and appearance of the hand. There should be a linear flow from the shoulder, along the arm, out to the hands. This was demonstrated in Figure 84 in Chapter 3.

In the following demonstrations of three common hand positions in portrait poses I'll acquaint you with a method of rendering hands loosely in compressed charcoal. I coat an illustration board a few times with acrylic gesso. (I draw the masculine hands on boards that have a rougher texture than the boards for the feminine hands.)

Compressed charcoal comes either in large square or round sticks, and is a bit clumsy to use. I can get some detail with it, but not too much. I rub or blend the tones with a piece of folded paper towel. If the charcoal isn't too rubbed in, a kneaded eraser will pick up highlights, but to really erase it thoroughly, you have to use a hard eraser, such as a typewriter eraser.

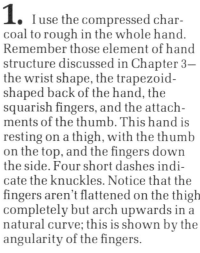

1. I use the compressed charcoal to rough in the whole hand. Remember those element of hand structure discussed in Chapter 3—the wrist shape, the trapezoid-shaped back of the hand, the squarish fingers, and the attachments of the thumb. This hand is resting on a thigh, with the thumb on the top, and the fingers down the side. Four short dashes indicate the knuckles. Notice that the fingers aren't flattened on the thigh completely but arch upwards in a natural curve; this is shown by the angularity of the fingers.

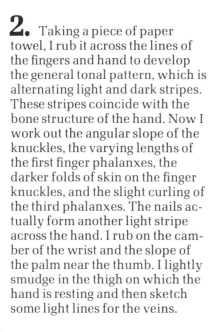

2. Taking a piece of paper towel, I rub it across the lines of the fingers and hand to develop the general tonal pattern, which is alternating light and dark stripes. These stripes coincide with the bone structure of the hand. Now I work out the angular slope of the knuckles, the varying lengths of the first finger phalanxes, the darker folds of skin on the finger knuckles, and the slight curling of the third phalanxes. The nails actually form another light stripe across the hand. I rub on the camber of the wrist and the slope of the palm near the thumb. I lightly smudge in the thigh on which the hand is resting and then sketch some light lines for the veins.

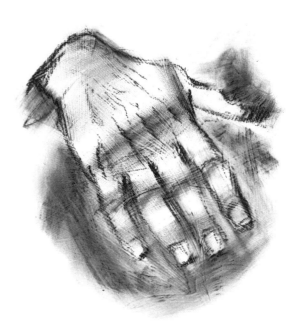

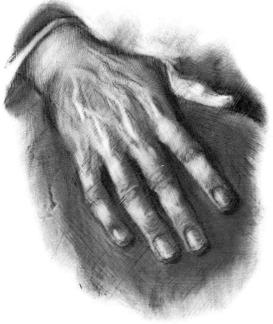

3. I add more charcoal, with confidence now because I know where it should be placed. I rub in heavy darks between the fingers, next to the thumb, and around the wrist, blending toward the center of the hand to give it a rounded appearance. I erase out highlights along the fingers and veins and also on the side of the thumb. I don't let the texture of the board influence me, developing the tone as though this texture isn't there.

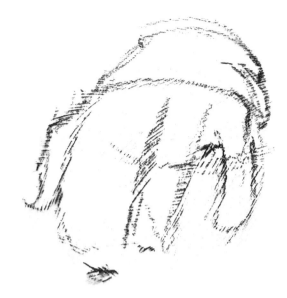

Foreshortened View

1. I see this hand from a sort of cross-section viewpoint, with overlapping ovals forming the wrist, palm, back of the hand, and finger area. In this pose, the little finger spreads apart from the others and is shorter and more curved. I delineate the ring finger from the vague curving contour on the left which represents the index and middle fingers. Again, notice how the thumb is an adjunct to the side of the hand.

2. The hand is lit from the front so that the finger area contains the lightest tone used in the drawing. I rub a middle tone over other surfaces, such as the back of the hand and the joints of the index and middle fingers. Using a stomp, I smear some of the charcoal lines of the first step and rub in knuckles, joints, and fingernails. I darken the tones between the index and middle fingers and around the wrist, adding and blending more charcoal. These points establish the low key.

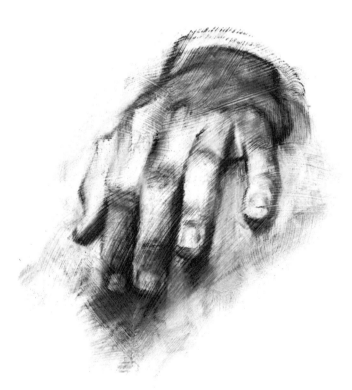

3. I see that an adjustment in the drawing is necessary. The phalanxes of the three right fingers need to be foreshortened, thus lowering the knuckle line. I add a faint tone to the fingers to subdue the highlights, being careful to use halftones that round out the fingers without destroying their squarishness. Using an eraser, I lift out material from the nails to give them shape and details. Notice that they're not completely formed—edges here and there are lost and left to the imagination. This is the essence of charcoal rendering. The nail on the little finger is designated by one sharp line under the nail— perhaps the only sharply defined line in the picture. The contour line of the thumb is wispy and almost disappears near the knuckle.

Side View

1. A feminine hand resting on the arm of a chair is apt to appear drooping in this manner. This position gives a graceful bend to the wrist, which is especially emphasized when the fingertips rest on a surface below.

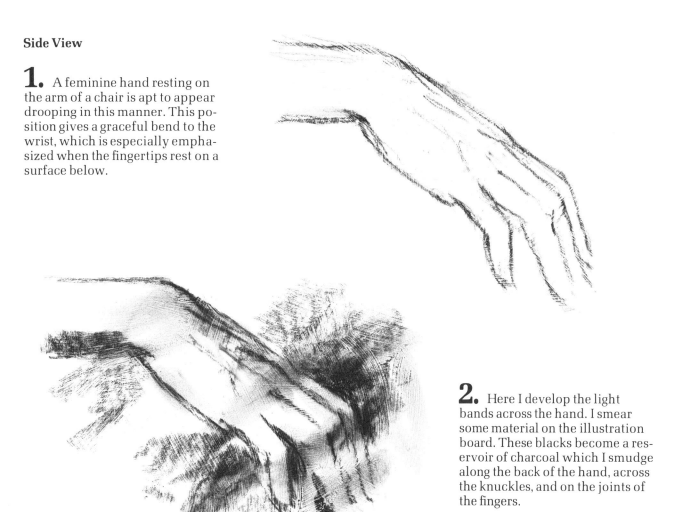

2. Here I develop the light bands across the hand. I smear some material on the illustration board. These blacks become a reservoir of charcoal which I smudge along the back of the hand, across the knuckles, and on the joints of the fingers.

3. I do more modeling of the hand. There are some problems. For example, the veins seem exaggerated and the hand looks too dark. Also, the hand looks less graceful than in the first step because I have flattened the angle of the wrist. However, the drawing is acceptable, with the edges of the fingers blending together as I want them to. (This is good on the feminine hand.) I add some sparklers (highlights) next to the shadows between the fingers.

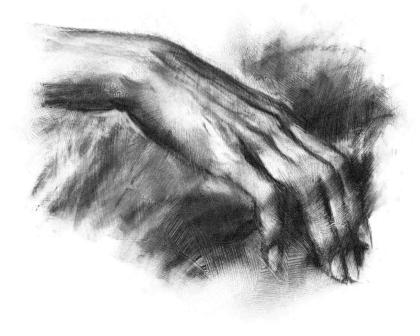

15.
Woman in
Charcoal

The following portrait is a copy of
one that I did from a photograph.
The woman's husband commis-
sioned the sketch for a birthday
surprise, so I never actually saw
her at all. He assured me that she
did look like the photo and that's
all I had to go on. I had to follow
the picture very faithfully, with-
out any interpretive effort. He told
me a little about her, but that's dif-
ferent from actually meeting the
subject, since my reaction to her
might not have been the same as
his. Always keep in mind that
what you're really doing when
you're drawing a portrait from a
photo is making a portrait of the
photograph, not of the person.
Furthermore, I've noticed that if
I'm shown a photograph of a per-
son before I meet him, I sometimes
conjure up a personality to fit the
photo. Later, when I meet him, I
find I have to alter my conception
of him, and then even the photo-
graph looks different to me! Any
such blind impressions based only
on photographs are sure to have
some kind of influence on your
portraiture.

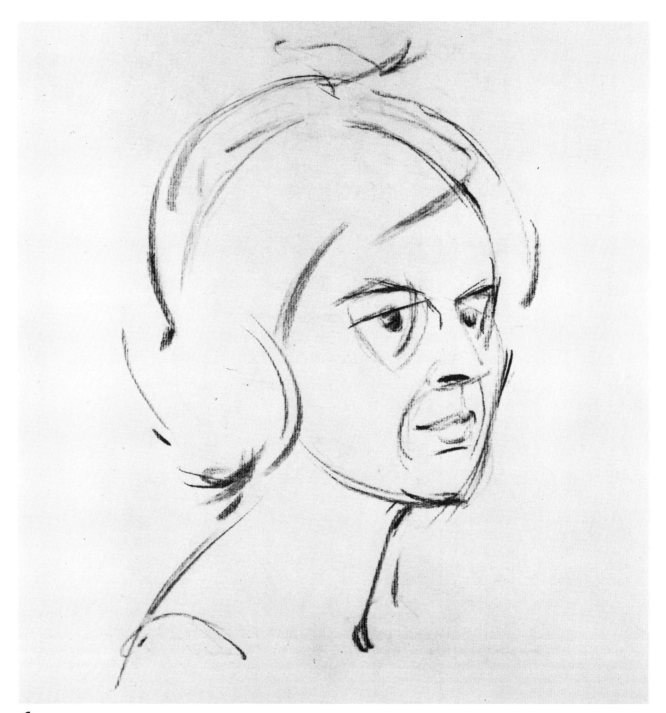

1. I start the portrait with a simple outline of the head in vine charcoal. (If you'll check back to Chapter 2 you'll find simplified analyses of the head.)

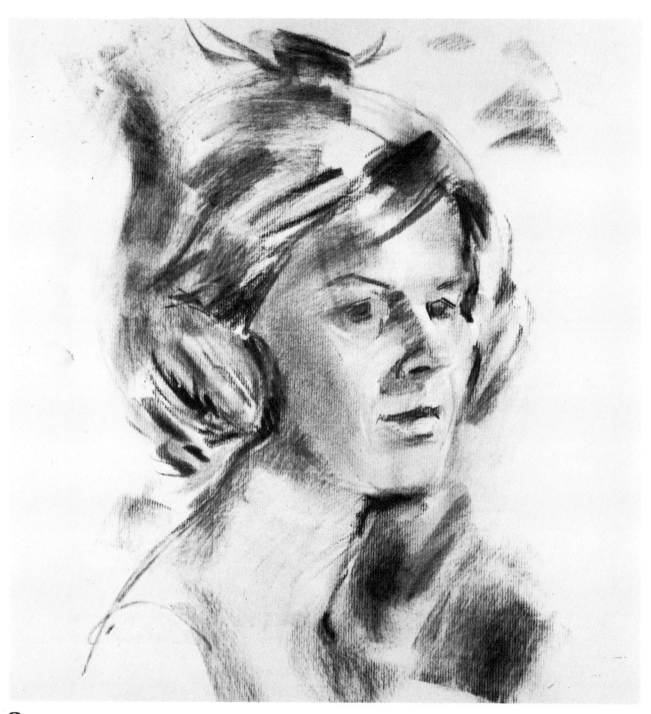

2. Here I begin a tonal layout, making broad sweeps with the sides of a piece of charcoal. Since this subject is a redhead, I use variegated tones ranging from black to almost white. Next, I add a few charcoal strokes to make the hair shiny, casual, fluffy at places, and wispy in others—but all in a definite order. I indicate the shape of the face and features, such as the large side plane of the face and the darker side plane of the nose and its shadow. The arrangement of larger tones also gives me a good idea of where the highlights should be, such as the one on the nose and upper lip.

I begin tracking the eyes by estimating the position of the cornea. I sketch in just a few accents such as the eyebrows, the eyelids, the ridge of the nose, the nostril, and the lips. These details may seem premature, but they do help keep the essential drawing in line. The youthful beauty of the model also seems to require a soft touch around the jaw and chin.

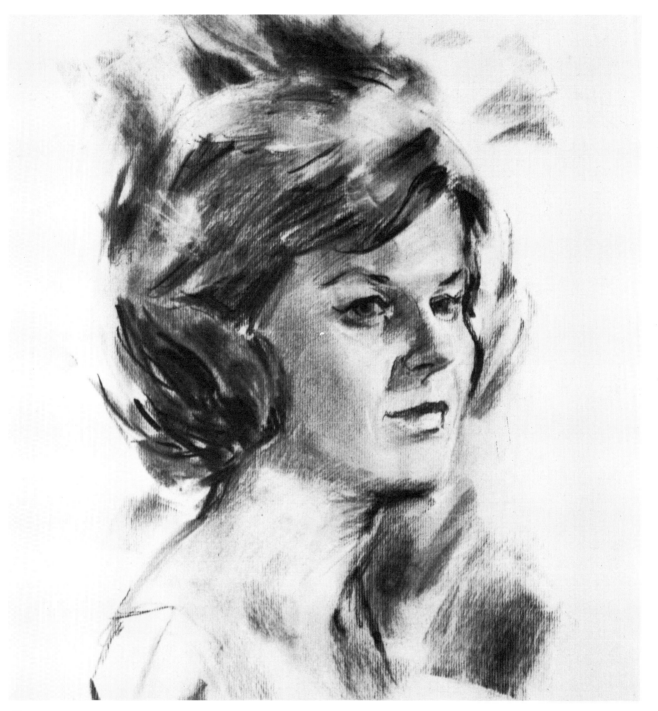

3. The picture emerges as I start to pull the hairstyle together. First I join the tonal values to get some idea of the overall design of the coiffure. Then I concentrate on the forelock, giving it a definite shape and establishing the effect of the lighting upon it. Now I also begin to work on the eyes. I shape the lower lids and accentuate the upper lids; they are an important aspect of the overall eye construction. Notice how the eyebrows line up in the flat X configuration demonstrated in **Figure 42** of Chapter 2. Moving downward in the face, I smooth out the nose shadow, sharply define the bridge as it hides the eye (this helps to establish the shape of the eye socket), and redefine the underside of the nose and the mouth. I shade in the plane beneath the chin and then rough in the depression of the neck and the top of the dress.

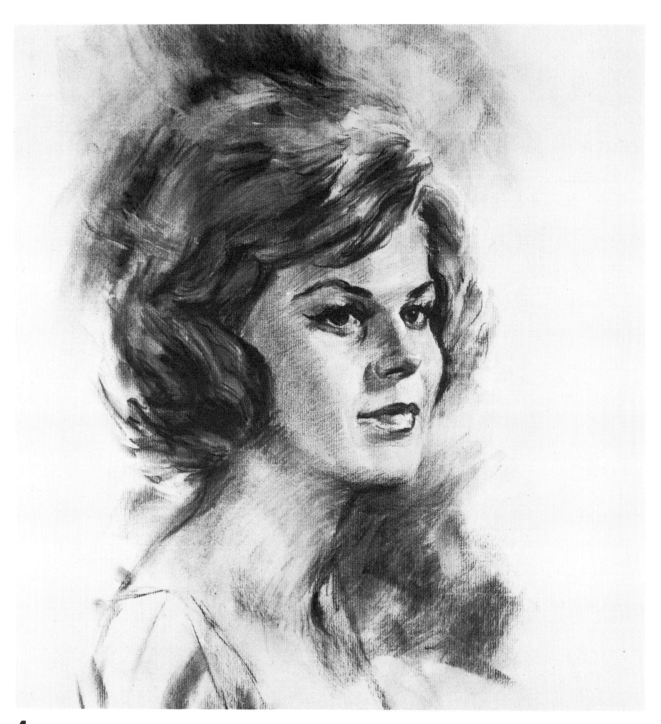

4. I use my finger and kneaded eraser to soften the hair here and there, and pick out wispy hairs at the crown, across the forehead, and on the right side of the face. The vitality of healthy hair is demonstrated by softness (around the periphery) and by shine, but discipline is necessary to keep from making the highlights too strong. I keep the highlights at a minimum on top and in front, and subdue the tonal values of the sheen at the back to keep it subordinate to the front. I further develop the eyes by adding the lashes, darkening the lash line, and defining the lower lid. To give the alert eyes a sparkle, I indicate a highlight on each pupil, making the highlight in the right eye stronger, so that it is the dominant eye.

I work on the nose and mouth to better develop their shape. The mouth seems a little too hard-edged, but this is one of the problems of drawing from a photograph. The photo had an overall harshness which seemed to give the woman a kind of sophistication that her husband described and liked. By keeping a lot of her facial contours soft, I managed to convey a hint of personality, making this something other than a portrait of a photograph. For a finishing touch, I accent the pit of her neck, vaguely indicate the lines of her dress, and smooth out the tones in the background.

16.
Child in Charcoal

The task of drawing children is almost easier than getting them to sit still. Parents will supply you with children for portraiture, but you'll have to decide if you have the stamina and patience to put up with them. I'm not usually enthusiastic about drawing from photographs, but with children it's the only merciful way to do it. Of course, the age of the child makes a difference. As a rule of thumb, any child under six is camera material, and even after that age you're still shooting at a moving target. Children are so busy, so easily bored, and so energetic.

I advise you to shoot a couple of rolls of black and white film, as fine grain as possible. At the present time, Eastman Kodak has stopped making my favorite kind—Panatomic-X—but I think you can get a similar film in an Ilford brand. If you resist the idea of photographs and attempt live sittings, you'll probably find that your portraits are rather sketchy—a quality that is more apt to convey the spirit of the child and capture a fleeting bit of his beauty than a studied, more finished work.

If possible, either draw the live sketch or take the photographs without the child's parents around. Deprived of a parental audience, the child will be less inclined to whine or misbehave. When the child is feeling well and not tired (morning sittings are best), he can be coaxed into many poses. However, you may have to play games or supply playthings to bring out the spark you're looking for in the child.

An animated pose is good if the child is naturally exuberant; his bright, sparkling eyes imply that he's healthy and full of life. An open-mouthed smile isn't bad on a child either, provided that it truly portrays his high spirits. Some children just naturally have a serious demeanor, but their innocence should not be overlooked. An air of wide-eyed innocence will keep a serious pose from losing its childlike quality.

It's important to pinpoint the child's correct age. To do so, you must pay careful attention to the length of the nose and to the placement of the eyeline, which will be higher as the child gets older. (Remember that the growth of the bone structure of the face and jaw lags behind that of the cranium.) Since the child starts losing the baby teeth at about six or seven, this age is a bad time to do portraits. Also, girls from seven to eleven grow very quickly and become awkward and gangling, although boys mature slower.

Children's portraits should be less than life size, perhaps three-quarters or one-half. This adds to the diminutive effect you're after; life size or more creates an illusion of adulthood or even grotesqueness.

People who want portraits of their children often vacillate about the best time of the child's life to have a portrait done. Since the child's cherished looks change all too quickly, you have to encourage the parents to go ahead with the portrait without seeming to do a hard sell.

In the following demonstration, I use vine charcoal on D'Arches Ingres paper.

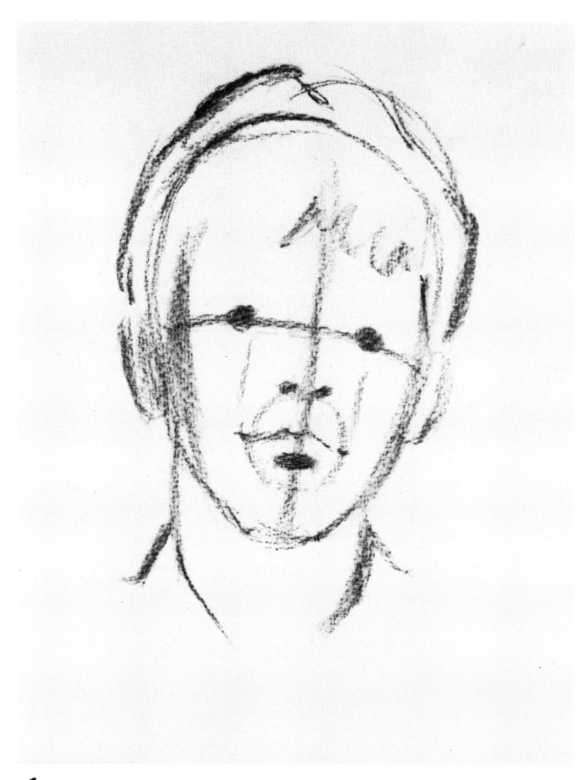

1. This first step is more basic than I would normally bother with in a small charcoal portrait like this—usually after some experience in drawing heads, you could jump ahead to start the next step. But if you want to review the rudiments of head structure, they are: an oval for the head, a central dividing line down the face, the axis of the eyes (notice it's lower on a child), and placement of the mouth within a circle bounded by the nose and chin. Then I rough in the hair, eyes, and neck.

2. This stage is really nothing more than establishing the basic tonal structure. I wield the charcoal in a loose, free approach—to develop a light and shadow pattern—that later evolves into shaping and placing forms.

3. Here I strongly reinforce the correct values of the facial shapes. Notice the obvious separation of tones; this represents the various planes and their interrelationships throughout the face and hair areas. There's also nothing subtle about the erased-out highlights, since they give me structural checkpoints as well as setting the high key. The boy's features are fairly symmetrical, almost "ideal"; they are easily drawn according to the step-by-step instructions in Chapter 2. If you find any mistakes in the drawing, now is the time to correct them. Correction is simple with a kneaded eraser or chamois, since nothing has been rubbed in and the paper is not stained.

4. Now I see that the jaw is too long for a six-year-old-boy. If I change the jaw, I find I must also raise the upper lip a slight degree. The hair should be a little fluffier, which gives him a younger appearance, too. This youngster is getting to an age where the bridge of the nose is becoming more defined, so I indicate this by darkening the tones on each side of his nose. He's also slightly tanned. My overall tone plan for his face is a range of values 1 to 4. The smiling pose in this case is good, although he looks like he's thinking of some mischief—like hitting me!

17.
Man in
Charcoal

For this portrait, I had to hurry and catch Al before his wife got after him to get a haircut. I can't quite imagine my wild art director friend any other way than with a delightfully bushy head of hair and an 1890 mustache looping up to his sideburns. His appearance seems to mirror his vitality of thinking—the hair could just as well be ideas flying out of his mind! Don't mistake this pose for one of *almost* composure! You can be sure that it's only an infinitesimal pause before the next movement takes place. Only a fast camera lens could cut a slice of his verve and restlessness. Al usually squats in the chair, or even sits on top of a table with both feet under him. However, for the portrait, I think a pose with one foot tucked up will be enough! You probably won't do many portraits with the foot pulled up into the picture area like this, although it's an appropriate pose in this case. An interesting contrast to the casual position is Al's rather formal attire of vest and tie. This isn't a calculated paradox; it's part of his personality.

You should always remember that although there are many novel ways to pose a person, you must have a fairly good motive for using an offbeat attitude. Of the different poses Al tried out for me, one pose that I liked was of Al leaning over the drawing board, scratching his head. I wondered, though, if his family would like to see him scratching for years to come! Another neat pose was one of Al with a strong spotlight in back of him while he sat with his body turned away but his face toward me. The primary light came through the outer edge of his hair while his face was lit in a low key by a secondary light. I was tempted to use this pose but I wanted his hands in the portrait. Unless I arranged the hands in a contorted pose, they wouldn't have shown. When he sat in yet another position at the drawing board with the light straight on his face, he had a tendency to look too fierce and formidable—which he isn't. So the question was, what kind of pose would portray a man that is vital yet gentle, constantly on the move, brilliant, and ca-

pable? I wanted to amalgamate these considerations with such inorganic things as the lighting and perspective in order to render a three-dimensional effect. As a last, but very important consideration, I tried to avoid too cute or too clever a pose. When my mind is boggled by all these conditions, I guess I just go by instinct in choosing a pose. If I feel that there are a few valid justifications for my choice, I don't think I've bombed completely.

In this portrait, the presence of a body, arms, and hands raises the problem of making the parts work together cohesively. Not only should the proportions of each element correctly relate to the others, but their proportions should also be individually correct. For example, the hands should be large enough to bring them forward in the portrait but should not suffer photographic distortion.

To draw Al's portrait, I use both vine and compressed charcoal on a white, 20″ x 30″ illustration board. I also use a paper stomp to rub and blend the tones.

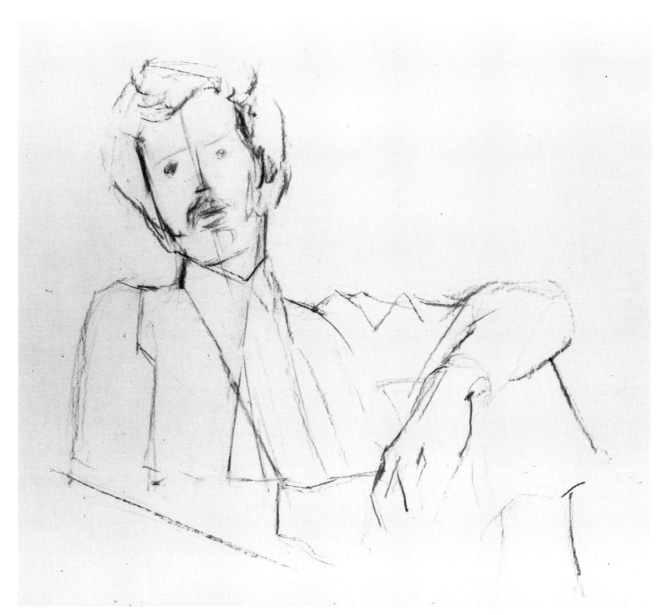

1. The main difficulty in starting out with this project is to place the head properly in relation to the mass of the body, arms, and leg. The body consists of many geometrical shapes, rectangles, and triangles. These shapes triangulate through the collar and neck. Notice how the axis of the head bisects these triangles to form others. They help establish the position, size, and attitude of the head. Triangles are easy to see, draw, and to proportion in relationship to each other. This was all done with a piece of vine charcoal, which will be absorbed later by the compressed charcoal.

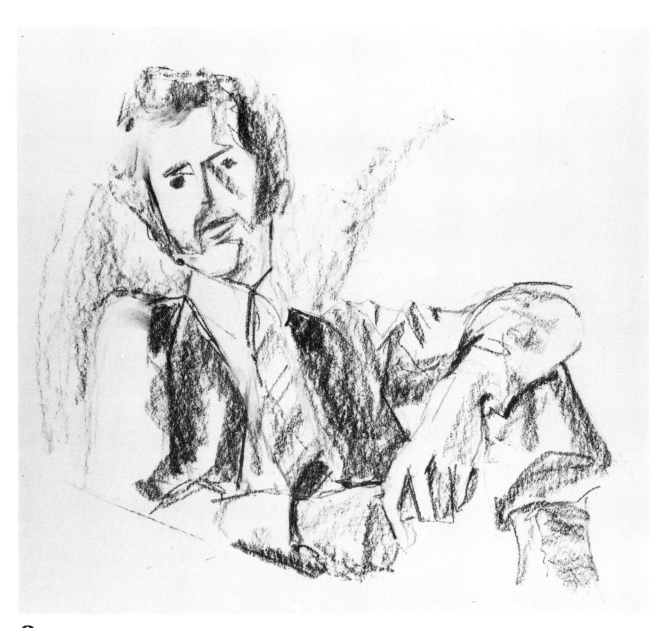

2. Having established the guideposts in the previous sketch, I immediately begin a kind of tonal pattern with compressed charcoal. Actually, these tones are only guides, too, since they're not the final shades but, rather, several notes too high. They help you see if the drawing is correct; a tonal pattern gives you a better idea than a line drawing might.

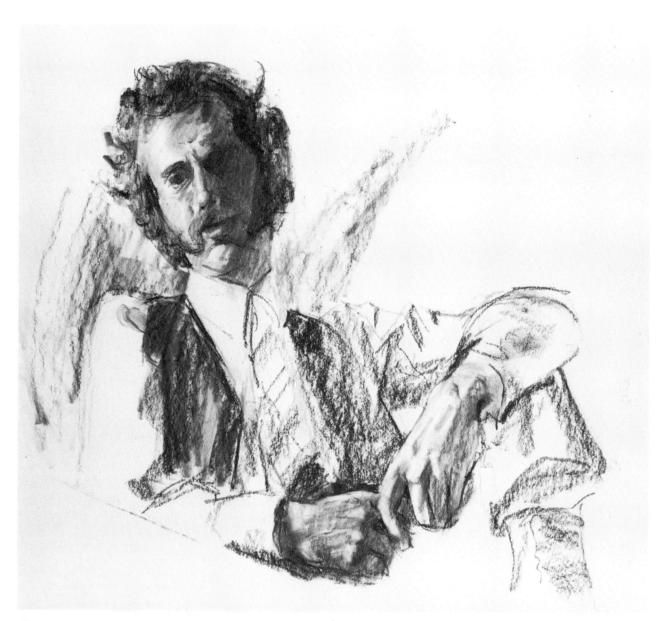

3. Here I lay in the tones quite heavily with compressed charcoal and rub them with a paper stomp. Notice that I'm careful to wipe the stomp clean when blending light tones. If I need more black material on the stomp, I simply rub it on one of the black areas (like in the hair), then use it elsewhere, such as in the face and hands. I establish a kind of light and shadow relationship between them. I may leave the body done in a loose manner. I limit the shadow side of the face to one tonal value; otherwise, if I started working on all the little nuances, like around the eye, I'd probably use values too light and too diverse. I also begin darkening the vest with tones in context with hands and face.

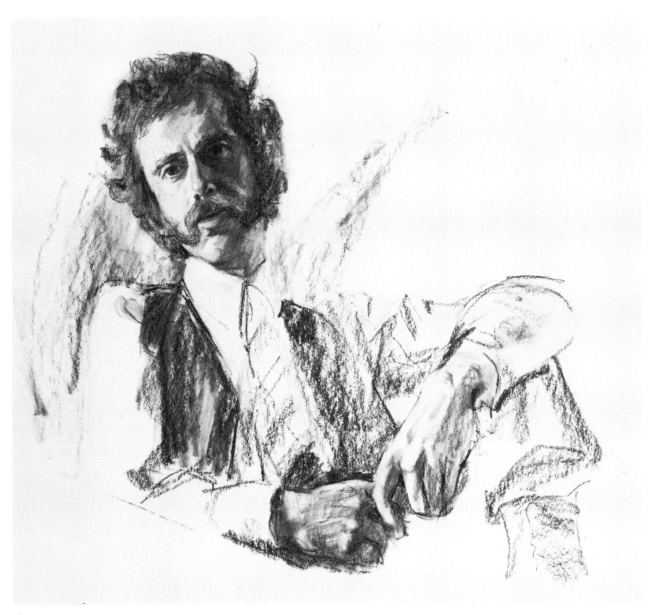

4. I add much more tone to the hair and shape it around the periphery as well as the face, the forehead, and where it meets the mustache. I finish much on the face, developing all the features, lifting out highlights on the eye and cheek of the shadow side using a kneaded eraser. Notice the angularity of these highlights. The inner corner of that eye should fade off into very dark black; be careful to avoid hard edges in that area too.

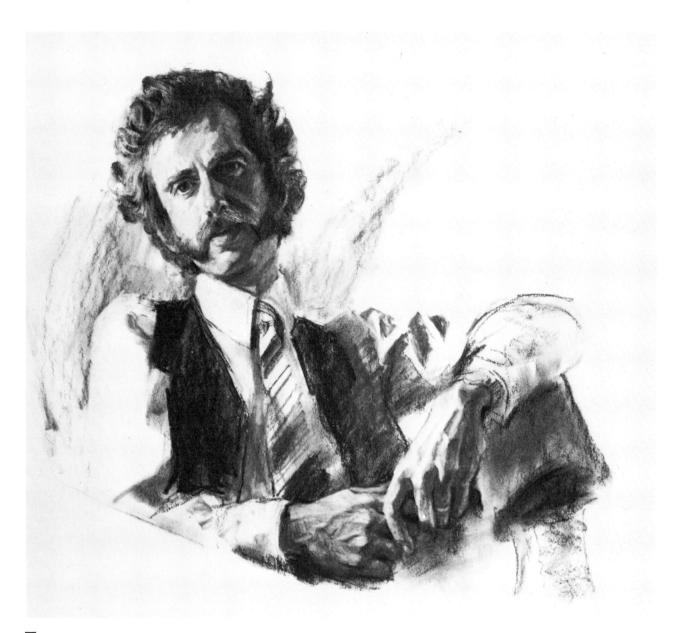

5. I do a little bit more work on the head, concentrating mainly on the hair. I lift out some highlights with a very hard ink eraser, and bring the ears into evidence by erasing out some of the hair so their rims just barely show through the hair. Again using the hard, pointed eraser, I soften the edges of the mustache and pick out a few highlighted hairs. Al has his mouth open as if he were about to speak, so I very subtly indicate a few teeth. Great care must be taken because only a hint is necessary. I then proceed to work more on his clothes by adding charcoal and rubbing either with the stomp or a paper towel. Although Al's suit and vest are in reality black, the only place that I use black is directly under the head. This makes that area look like it's bathed in a strong light, and also provides good contrast to the white shirt, which draws the viewer's eye. The pants leg and boot are also very black.

18.
Woman
in Pencil

In this project we'll explore two things: (1) the drawing of an Oriental face, and (2) a black and white carbon pencil rendering on toned paper.

Most people notice the difference in the shape of the eyes in the Oriental and the Occidental face. However, it's naive to merely say that Oriental eyes are "slanted." If you study eye structure in depth, you'll find that the uptilted, "almond-shaped" eye is a very basic characteristic in any race. The axis of the eyeball from the inner corner to the outer corner slants upward slightly, as shown in Figure 56, Chapter 2. Remember, too, that the eye orbits also slant slightly, due to the curvature of the surrounding bone structure. This slanting effect has come to be associated with the Oriental eye, because of the facial construction around the brow area characteristic of the Oriental people. Of course, there are many illusive and subtle distinctions in individual facial structures, and I'm making such a generalization *only* to

provide a basis for drawing the Oriental eye structure.

In my portrait of Harriet, her superciliary eminences aren't prominent, resulting in less of a brow overhang, with a straight drop of the flesh down in an unbroken plane to the eyelids. This tends to give the eyeballs a protruding look, bringing them forward, out of the skull a little. Also, contrasted with the Occidental eye, her upper lid doesn't seem to arch over the bulge of the cornea. When the lid of the Occidental eye arches over the cornea, this counteracts the slanting axis of the eye. However, the Oriental eye actually emphasizes that axis, since in many cases the crease on the upper lid appears nonexistent. (Harriet's have a tiny line.) This slant is even further emphasized by the almost puffy smoothness under the eye, where the flesh doesn't fold under and wrinkle as in the Occidental eye. The flatness of the brow also eliminates any deep recesses in the eye corners next to the nose. The nasal bone doesn't protrude either, and al-

though the nostrils aren't spread, the nose seems to flatten against the face. This kind of skull structure makes it difficult to turn the eye, forehead, and cheek in a three-quarter view—the facial structure then seems to look boxy.

I rather enjoy doing a rendering of this kind with two extremes of values on a middle-tone paper, since you get a portrait very quickly, even with a sketchy treatment. On a larger portrait (I consider this 15" x 20" drawing large for a pencil drawing), the fine point of the pencil tends to inhibit my ability to develop masses of tones in a hurry. I find that I get calligraphic and the result is a little too feeble. Here I combine a rendering of volume by shading in the face and body, plus a shorthand interpretation of the arms and hands. Probably one or the other should be done completely, but I'll use this to demonstrate the variety of ways you can apply black and white pencils to toned paper (this is a tan-colored, Canson Mi-Teintes pastel paper).

1. I start with a soft (6B), black carbon pencil, using the side of the pencil point to rough in the forms. In some places it's hard to refrain from shading in areas of tones—like her left shoulder and arm. I'm always anxious to get into the tonal development of the character.

2. I continue to use the side of the pencil, almost "scumbling" in the larger masses of tones. I render these pretty loosely, except in the face where I don't want to lose the drawing. If I'm not certain of a line I don't put it in; instead, I kind of shade around the forms without any definite commitment. Notice that especially around the features—eyes, nose, and mouth—there are no outlines. I indicate the blacks around the face where I want a tonal comparison and introduce the white carbon pencil to add tonal dimension to the cheek plane, nose, and above the eye. I also roughly develop part of the dress.

3. Now I use a harder (2B) carbon pencil to go over a lot of softer pencil tones—especially on the face. I darken the tones of the hair, bringing it closer to its true blackness, although leaving some sheen. I do quite a bit of detailing around the eyes, giving them a slightly Occidental look by delineating the crease of her upper lid. Also, notice the basic squarishness of Harriet's brow and eyeline. I use more white pencil to bring out this form in the light, and to rim the upper lip and the nostril with a shiny line.

Next I work on the trim around the collar and sleeve, holding the black carbon pencil at right angles to the line and making short, jerky movements. I add more white to emphasize the collar's form and also to indicate the gathers around the collar. I "ghost" in the other arm since I haven't decided whether to finish it.

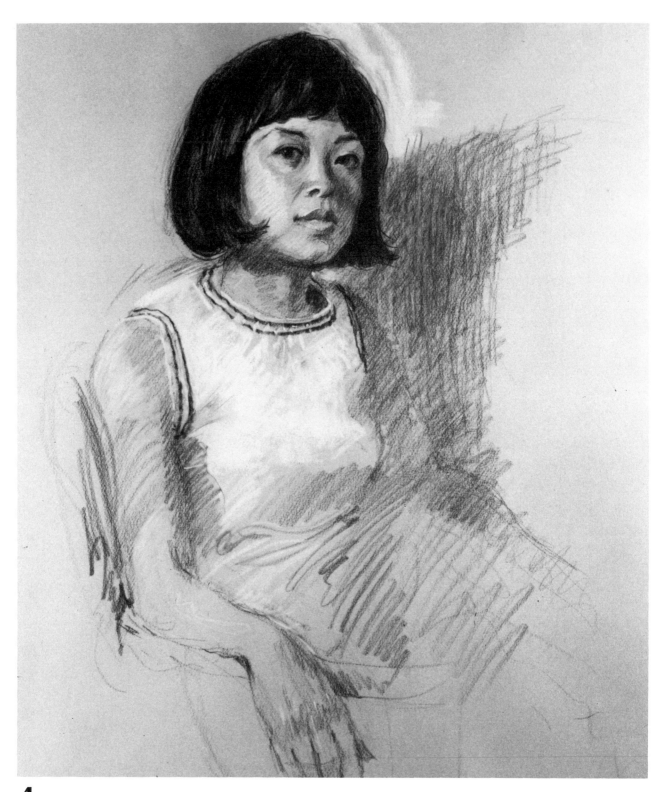

4. Here I do more shading with both pencils. I add even more black to the hair, and finer shading around all the facial tones. I strengthen the light plane on the cheek by shading it with the white pencil quite heavily. I continue to shape the lips that I started in Step 3. I add in more whites to give form to the dress and develop the other arm a little, since I'm thinking of drawing in the hand. There should be some indication of its presence; it bothers me to cut off a limb like that unless there's a good reason to do it. I darken the background shadow behind the arm to make it recede further.

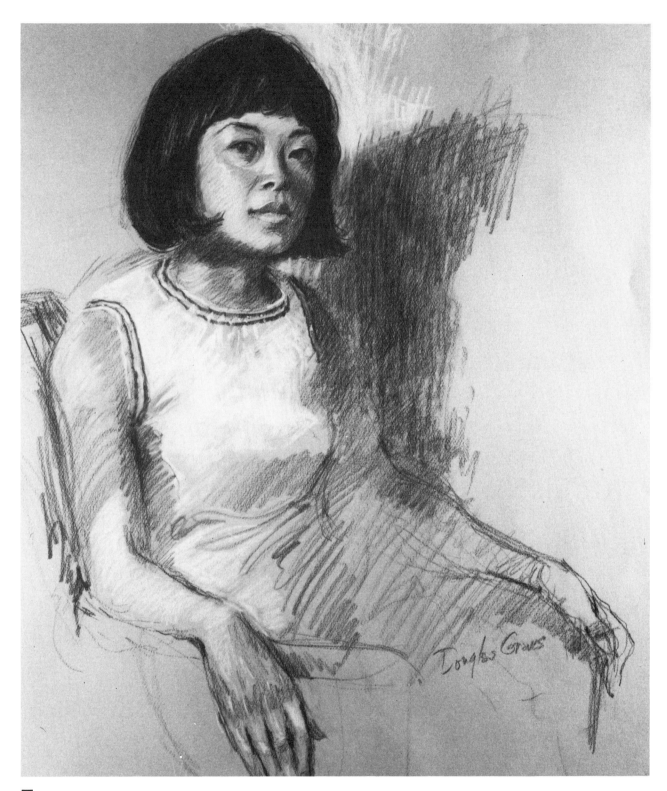

5. The addition of the other hand (although it's a shorthand version of it) seems to complete the portrait. I develop the detail on Harriet's right hand, which gives it dimension and brings it into focus. Notice, however, that the hand still doesn't dominate the face, which is the focal point of the portrait.

19.
Teenager in Pencil

Drawing teenagers can be fun because of their beauty and high spirits. It's a wonderful age—they're beginning to mature, to feel the urge for freedom and the need to conquer the world. It shows in their clear, dancing eyes, fresh skin, and liveliness of hair and dress. A pencil drawing is just right to convey all this, because pencil can be a lively medium when the technique is flowing and done with a verve of arm movements.

In this portrait of Cathy, I draw the face in light tones to portray a soft freshness, at the same time avoiding any slavishly smooth lines that might make the drawing hard and mechanical-looking. Long, straightish hair lends itself to swinging pencil strokes, more than short hair does. I couldn't resist the temptation to erase out highlights on the hair. The strands hanging on each side reflect almost equal amounts of light, but they are different shapes and sizes.

A smile isn't necessarily an open, laughing mouth, it can also be just a pleasant, happy expression. The dimples are a consequence of this expression and are difficult to show unless they're handled with care. Remember that lines show age and character, and these dimples aren't meant for that purpose.

For the portrait to look like Cathy, her eyes had to be slightly different—one eye, her left one, is a tiny bit higher than the other—not eccentric by any means, but just enough to make her Cathy. The lower lid dips a little deeper under her right eye also. I open the eyes somewhat to convey her intelligence, yet at the same time her eyes have to retain her smiling expression—by looking sparkling and crinkly at the corners.

1. You could start your sketch the conventional way with a direct, precise pencil outline. However, I'll do this sketch in a different way and I'll explain it to you in case you don't feel confident enough to plunge right in drawing on an expensive piece of illustration board. Do a preliminary sketch, actual size, on a tracing-paper pad, using a medium-soft 2B pencil. If you should get off to a bad start or it begins to go sour, tear that sheet off, slip it under the top sheet, and use it to begin another one, making contours where necessary. When you get a drawing that is satisfactory (don't exhaust yourself finishing it), blacken the back with a 4B pencil and then trace the outline on your illustration board with a hard 5H or 8H pencil. It's possible you might see some of these traced lines on my drawing.

2. Now I stroke in some of the strands of hair with a 2B pencil, and I try to give some semblance of form to the hair. I indicate a couple of dark areas next to the neck; these are the low key of the tonal scale in this drawing.

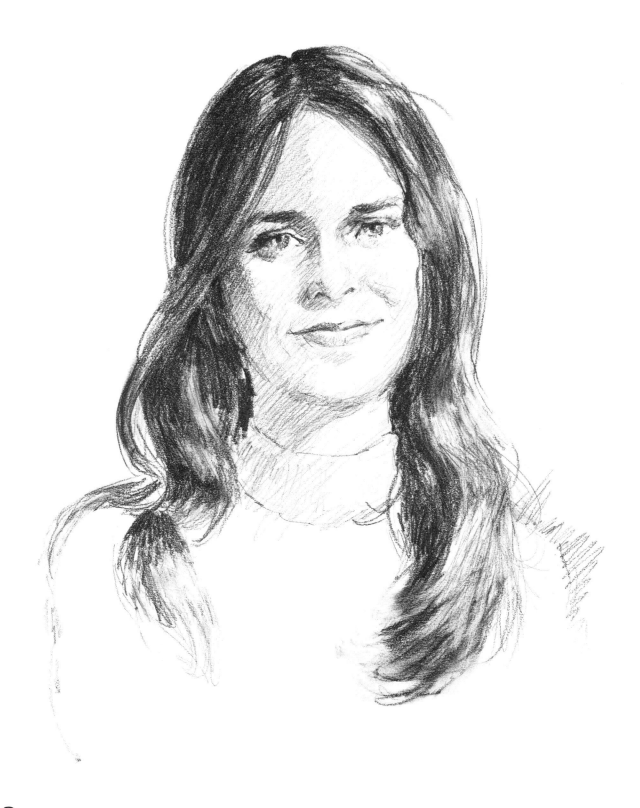

3. Here I work on the hair, developing its light and shadow pattern. I begin on the facial tones, keeping a smooth skin surface and making the edges soft; I also darken some areas around the eyes. Although I hesitate to really sharpen or define the drawing yet, still, I can see her likeness emerging. If the portrait isn't quite right in spots, I simply change it wherever necessary to bring out those forms correctly.

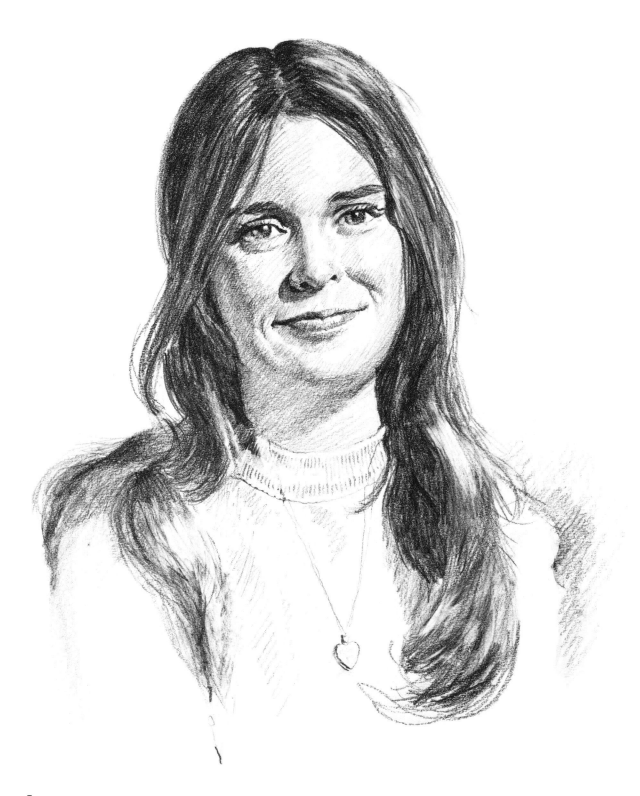

4. I erase the neckline of the sweater to make the neck look longer. Since everything is starting to fit into place, now I polish and smooth the tones and also make the edges sharper and more precise. I darken the lines around the eyes and blend the two values on the forehead together. I use a 2H pencil for the lightest values—those which surround the highlights—on the forehead and the rest of the face. I use a 2B pencil for the next darker tones. Notice that the 2B lines are not an open shading because they would have shown up as obvious lines and not tones, while the light 2H tones are open shading with definite lines, yet aren't as obvious. I finish the hair by softening some of the tones, especially at the ends of the strands. I've tried shading in the background for atmosphere in a portrait such as this, but it only detracted from the head. I like the cleaner, white silhouette.

20.
Man in Pencil

I spent many hours in Oliver Rodin's studio, next to mine, neglecting my own easel. (Yes, he was related to August Rodin, the great sculptor.) I was fascinated with stories of his early life in Europe, of Parisian artists and their cold garrets. Their long suffering wasn't without a humor and camaraderie that we painters seem to lack now. He had lots of advice to give me about what I should paint as well as how to do it. There were amusing stories and songs in French to go with this advice. He had produced theatrical shows at one time so there was quite a little ham in him and it was a natural thing for him to be willing to pose for me. I didn't do as many sketches or paintings of him as I wanted to, before he was gone. (I don't miss him simply for that reason, but I should point out that if you find a willing subject, don't be hesitant about having him sit for you.) Rodin's face was fascinating, sculpted by suffering and strife. His character lines were not grotesque, out of place, or misshapen, but rather, they enhanced the structure of the muscles and strong bones beautifully. His

hands were rugged, capable, worn from modeling clay, and hammering and chiseling marble, yet sensitive enough for the piano keyboard.

As for the mechanics of the actual drawing, you can see that the light comes from the windows in back of him, outlining his head and arms and shining through his white hair. Notice, however, that the hair tones around the forehead and ear appear rather dark, seeming to belie its true whiteness. The reason is that his hair doesn't have a smooth, planar surface like his shirt does, but instead has many tiny ridges and canyons formed by hair shafts. Therefore, the hair on the side cannot reflect a weak, indirect light as effectively as the shirt. So, unless the light shines directly upon the hair or through it, like at the top of the head, the hair often appears to be quite dark.

One problem here is the unity of the design as well as the correctness of the actual figure drawing, since the arms stretch away to a secondary object. I try to counter the oblique line of the arms with downward, linear pencil strokes; I don't want the strokes to be

spaced too evenly, giving it a machine-made effect, as in the shirt. I would prefer to develop the same loose feeling all over the face as in the arm, but then I couldn't explicitly designate all the character planes.

The greatest danger in this kind of drawing—pencil—is the temptation to finish one spot. Simply because of its pointed preciseness, pencil makes you more interested in details than in the concept of wholeness. It takes supreme mastery over the instrument to keep moving from one area to the next. A case in point is around the eyes, where your fingers irresistibly make precise pencil marks. I'm not suggesting anything of a metaphysical nature, this is simply a reversion to childhood habits. It's excusable to pick out some details just for "navigational" points, but it's best to keep moving to other parts of the portrait. When I work in one spot too long I find myself getting tense; I relieve this by laying in some massive tones in the bigger areas—thus bringing it all along together.

For this portrait I use a 19″ x 18″ Crescent illustration board.

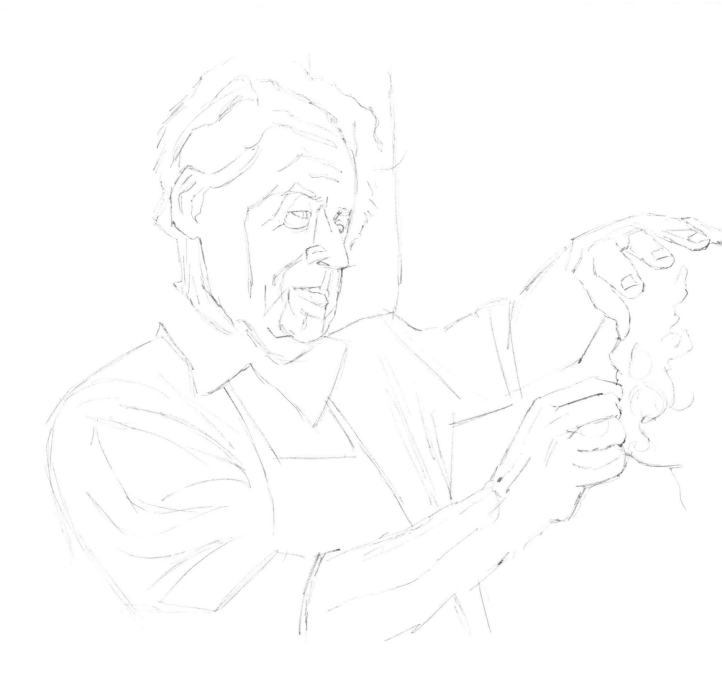

1. It would take a braver and less cautious person than myself to start a pencil sketch any other way than by a careful mapping-out process. A one-go technique requires a delineation of exactly where areas of tone will be. Though the final effect is tonal, it is not a painting procedure. Use a 4H pencil, keeping your lines lighter than this reproduction, as I had to darken these for clarity.

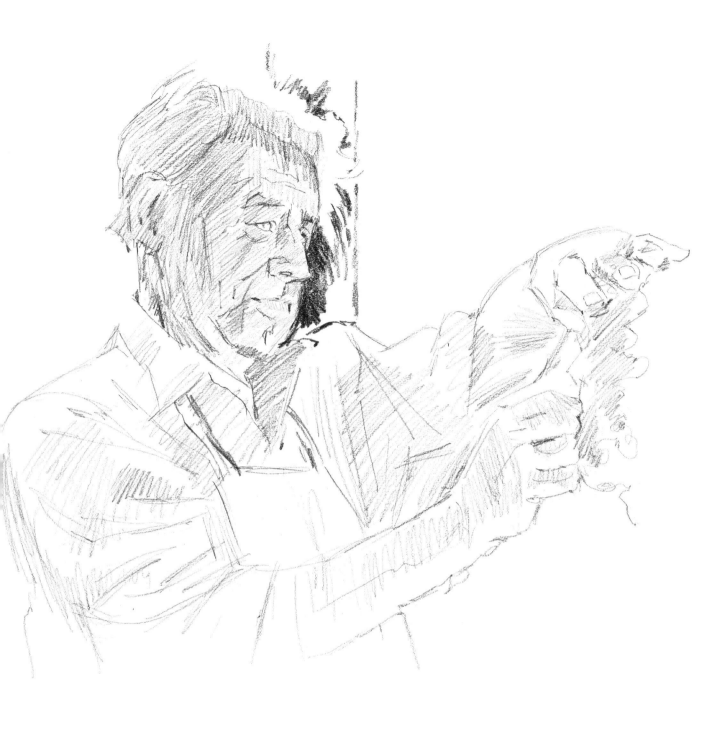

2. Here I begin stroking in the tones. You can start at the top as well as anywhere else but you should move over the entire picture to get a proper development of the tonal structure. It ranges from the black of the window bar (2B pencil), to the apron string, to the shadows between the fingers, to the fine preliminary shading on the lips (4H pencil).

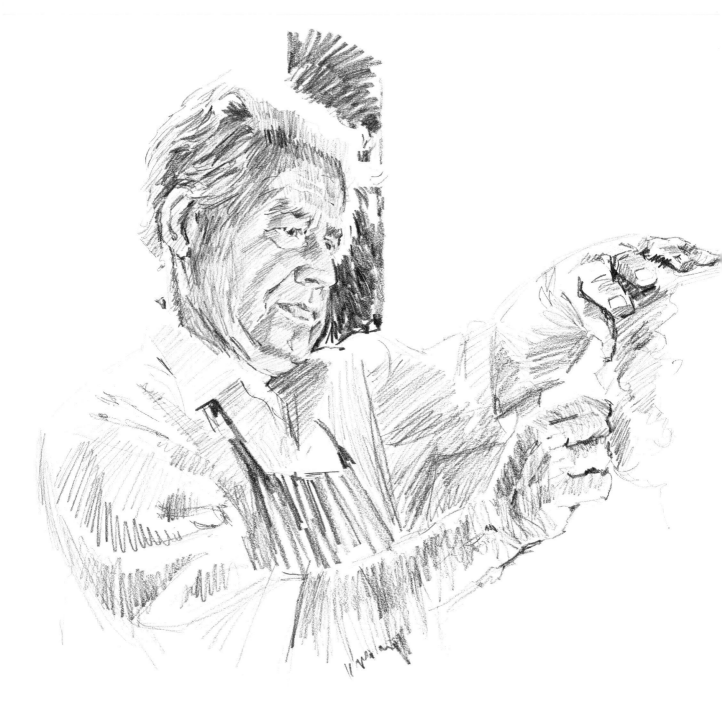

3. I make the window structure heavier—this is a good design device for giving an emotional solidity to the picture, and also silhouettes the halo formed by the white hair. I shade all of the face heavier with a combination of 2B and HB pencil strokes, most of which follow a general direction, although sometimes they follow the form of the facial structures. I think the only requirement is to continue shading in the same direction until a plane is completed. Care should be taken to shade up to and around highlights such as those on the forehead, around the eye structure, nose, and mouth. Remember, as I mentioned in Chapter 3, that stroking across the form can create both form and texture.

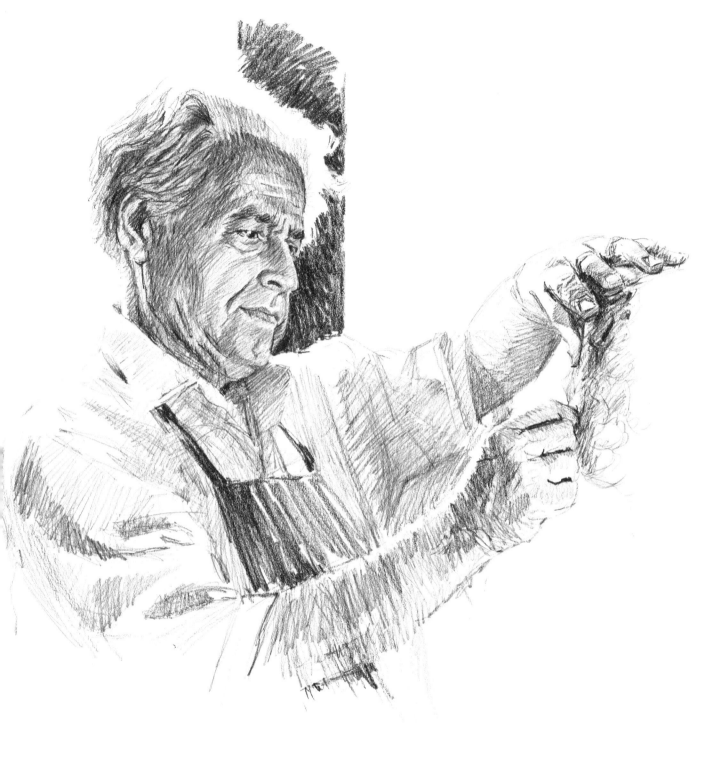

4. Using Using 2B, 2H, and HB pencils, I overshade and darken the values to develop the closeknit tones that I want on the face, as center of interest. You'll probably find it difficult to control the interrelating tones because of the linear technique necessary with a pencil. You should constantly step back to get an overall impression of the drawing, and to see specific fusions of the tonal planes.

21.
Woman
in Chalk

Miss Agnes Moorehead was one of my favorite actresses. I've watched her in many theatrical productions, movies, and on television. Because of her busy schedule, Miss Moorehead could only provide me with publicity photographs to work from. She gave me a good selection of pictures, however, from which I chose one I liked. Any actor or actress with an illustrious career has many "faces," but this photo best represents Miss Moorehead as I saw her. My impression is of a handsome woman, with a deceptively delicate and slender face, flaming red hair (I regret I can't show that color), and a touch of mystery in the eyes. The makeup on her mouth hides the firmness, determination, and sometimes cruelty, required by her roles, and also belies her background—that of a minister's daughter with a very strict, old-fashioned Puritan upbringing.

Overcoming the difficulties of drawing from photographs is always good experience for the portrait artist. How do I turn a photograph, taken with multiple light sources and then retouched, into an art form? Since the publicity photo has all the left side of Miss Moorehead's face blanched out, I must reconstruct her facial structure in subtle grays. To do this, I first decide which light source I will use. The strongest light

should fall predominantly on the face. Of course, when drawing from a photograph, you have to abide by the dominant lights and shadows that already exist. You can usually tell from the highlight on the eyeball which light source is the strongest. In this case, the light source is also indicated by the highlights on the hair.

Her eyes are heavily made up. Since I'd like this portrait to be less Miss Moorehead the actress and more the person, I soften the harsh eyelash lines and the hard outline of the lipstick. I also eliminate some of the highlights on the hair to simplify the tonal patterns there.

A good way to start a drawing in chalk is to use a color and value that is just barely darker than the paper. You can easily see the drawing, and later you can make corrections without the underdrawing being visible. For this portrait, I use a sheet of Canson Mi-Teintes gray pastel paper. The paper has a canvaslike surface on one side, which shows up when a piece of chalk is raked across it. If I don't want this pattern, I rub the chalk in with my fingers, which gives the paper a skinlike texture. Black and white pastel drawings are unusual; warm tones, such as sepia or umber would be preferable for a pastel monochrome drawing.

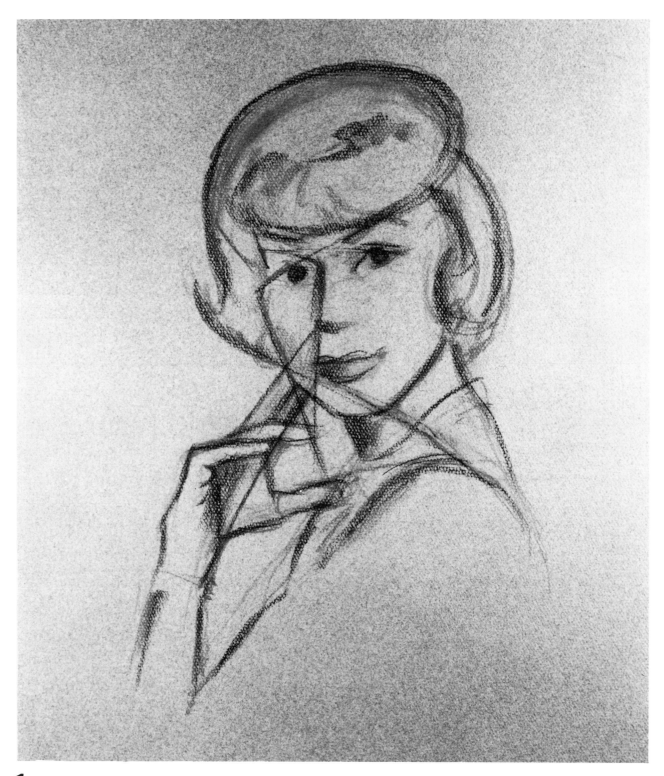

1. The head is slightly turned, so you see the nose outlined against the face. The ridge of the nose lines up with the outer corner of the mouth and the finger tip; the index and middle fingers line up with the tip of the nose. Notice how the intersection of these lines locate the hair, thumb, jaw, and cheekbone. Any line-ups like these help to make the drawing easier.

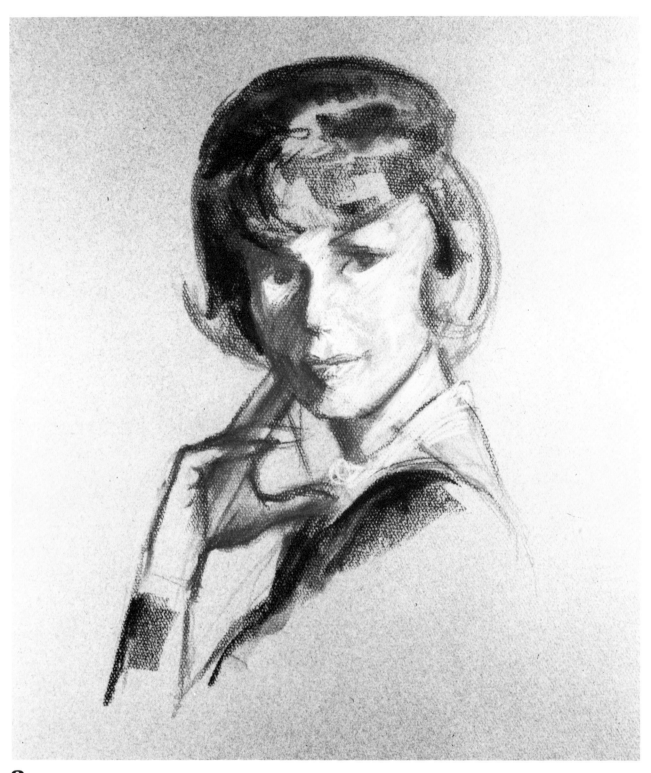

2. With broad sideswipes, I briskly lay in just the middle tones and blacks. These values are useful as the keynotes of the entire drawing. You can see that so far I've developed shapes and forms through a simple chiaroscuro effect. With a No. 1 gray chalk, I start to form the cheek that's totally missing in the publicity photo.

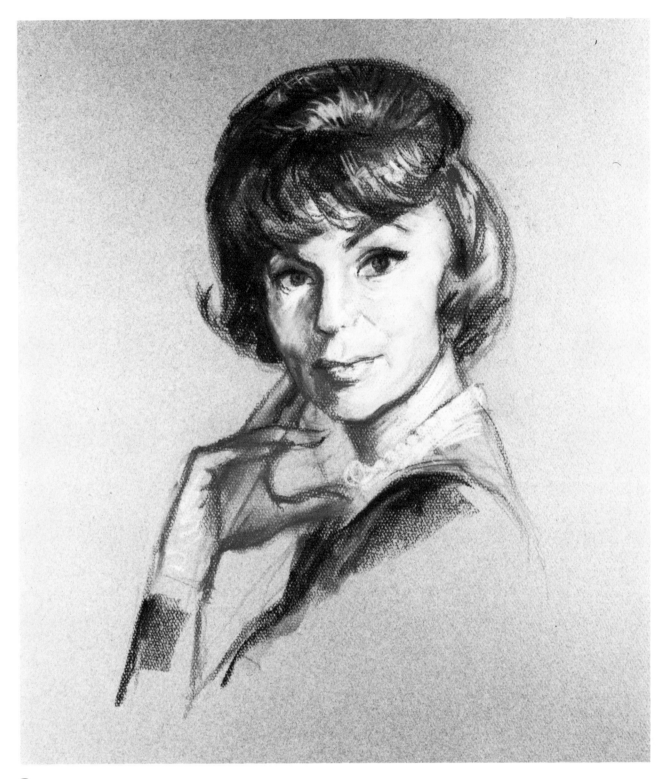

3. I add black values to the hair, giving it a more distinct form. This makes the values seem "jumpy" and so I smooth them out a little. I work more white chalk into the face. In doing so, I make the shadow side of the face too light, and chew up the edges of some of the facial features. I shape those up again, and at the same time add a little more detail, like the lash lines, the slight bulge of the cornea, the pupil, the ridge of the nose, and the nostrils. I reshape the mouth a bit and work in the dimples. To develop the shape of the fingers, I darken not only the periphery of the hand, but also the divisions between the fingers. (Notice how that secondary light source makes the hand seem less of an integral part of the portrait. This again is a problem with publicity photos; if I had composed this portrait, I would have brought the hand into a position in the primary light source.) I add a little white to the heel of the hand and then rough in the pearl necklace.

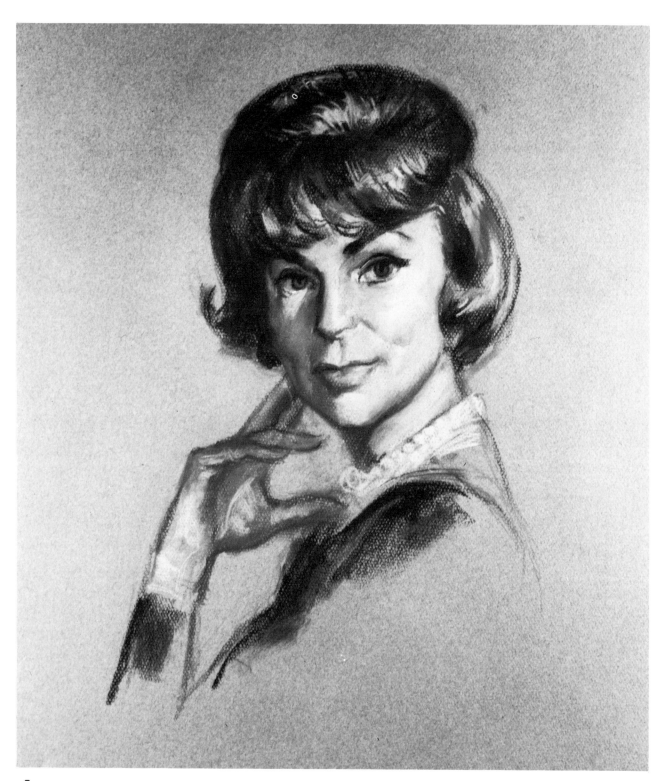

4. Now I see that the hair on the right needs additional darks and so does the area around the ear. I also darken the shadow side of the face and blend the edge of the nose plane and around the mouth. I carefully model the bone structure around the eye on the left and rub in the subtle forms on the light side of the face. I add more chalk and blend again, giving the paper's surface a fleshlike quality. I roll the edge of the jaw under, to give it dimension. (At this point, I begin to rub the pastel quite a lot with my fingers. I don't want the texture of the paper showing through, especially on the face.) Now I redefine the light side of the nose and wing, and soften and shape the mouth. I bring the hand into focus with additional tones.

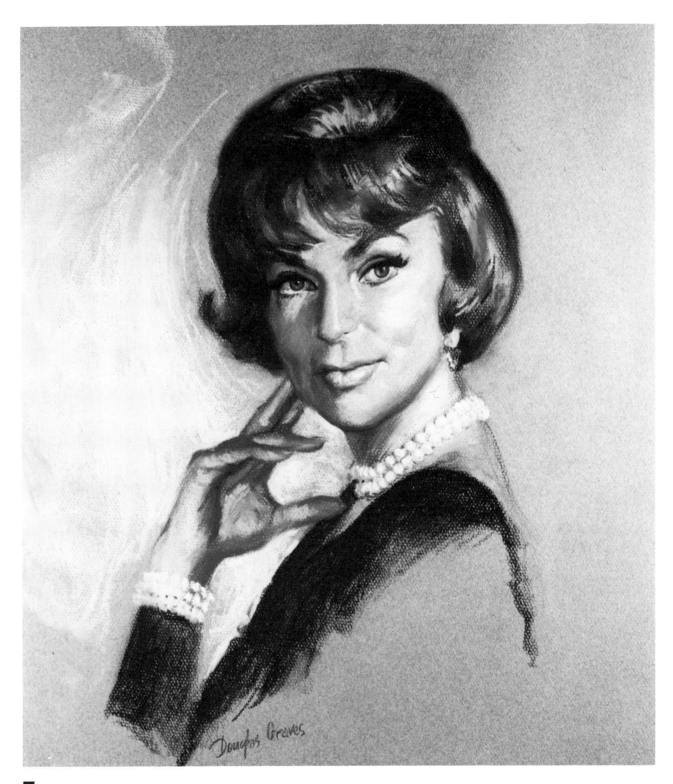

5. I darken the crown of her hair, as it seems too light. I "tailor" the whole periphery of the hair; it's too ragged and not soft enough. I add some details around the eyes, such as the lights on the rims of the lower lids, the glassy highlights on the eyeballs, the lighter tone of the irises, and the slightly heavier lashes. I finish off the mouth area by indicating the vertical creases and shine on the lips, softening the jawline even more, and reshaping the shadow cast by the chin. I further mold the hand, darkening the center of the palm and defining the finger separations. As a final touch, I include a pearl bracelet and give more wallop to the black dress vignette.

22.
Man in Chalk

It's a little frustrating to be unable to do a portrait of a black person in full color. They have fascinating skin color, running from light reddish brown to dark, rich, mahogany browns. Light reflections are unpredictable—pinks, oranges, and sometimes even blues and greens. But what's that got to do with drawing in black and white? Only that you can translate those skin hues into many tones, running the gamut of grays, with pure whites and pure blacks often occurring in juxtaposition. It's easy to do a strong rendering with such contrasts.

Bill Walker is another actor who has also expressed many moods in such roles as that of Reverend Sykes in the movie "To Kill a Mockingbird" and Maurice Stokes' father in "Maurie." Although it's tempting to try to amalgamate his different roles in a portrait, it wouldn't reflect his true personality—a smiling, gentle, and happy person—and this is how I would like to depict him.

In handling this drawing, I prefer to keep it rather broad in treatment, using wide, rather heavily wielded strokes. First, in a linear fashion, I very lightly locate approximately where everything will be. After that, I use the corner of a square chalk to indicate the planes of the face, the full-length edge for the wide areas such as his jacket, and the flat end of the chalk for the angular places on the cheek. Then I start to block in the forms in a lighter key, gradually lowering the tones. This process is less direct and means progressively laying on more material, stretching the value scale as you work. In other words, you retain the same structure and forms, while "sneaking up" on the correct tones. The details slowly grow clear as you work.

I managed to keep the impact of the light coming from his right, even though there's a persistent secondary light (theatrical lighting). It's a temptation to make a rendering like this too hard, but I think it's better not to blend or rub it too much. With such contrasting values in the skin, it could quickly become metallic-looking. I use a slightly gray Canson Mi-Teintes paper with a full range of gray chalks, plus square and round black and white pastel chalk.

1. First, I "find" the drawing with a very light-colored piece of chalk. (The reproduction of this step is a bit too dark to bring out the almost invisible lines.) I roughly connect the eye sockets to the nose outline, firmly establishing relative positions. This head pose is slightly off-center—which will be a challenge.

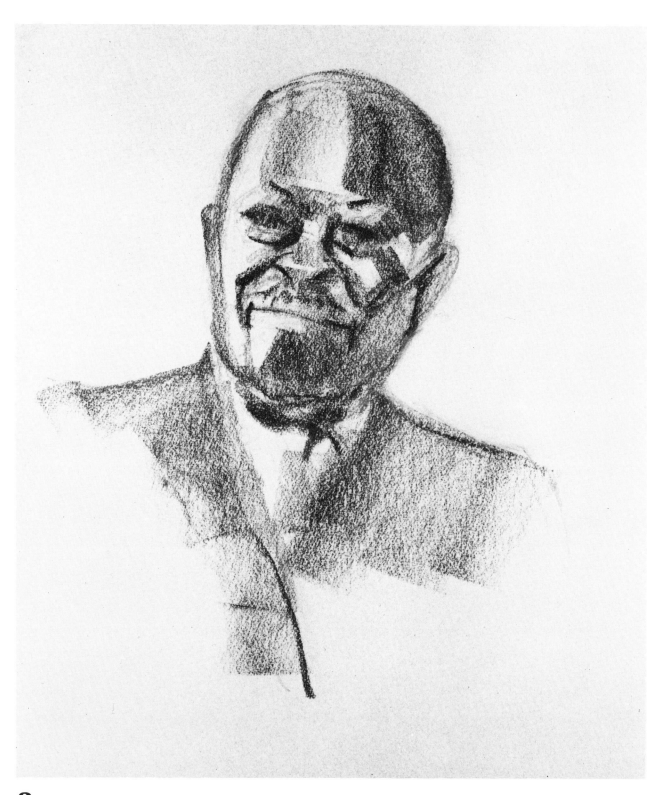

2. With broadly rendered strokes, I develop the shadow pattern as well as the facial forms (such as the curvature of the forehead and the angular bone structure around the eye sockets.) I make two light sweeps to angle the nose out, leaving the highlight, and indicate the recesses around the eyes and cheeks with heavy lines. This is more or less a quick impression of the stronger aspects of the head.

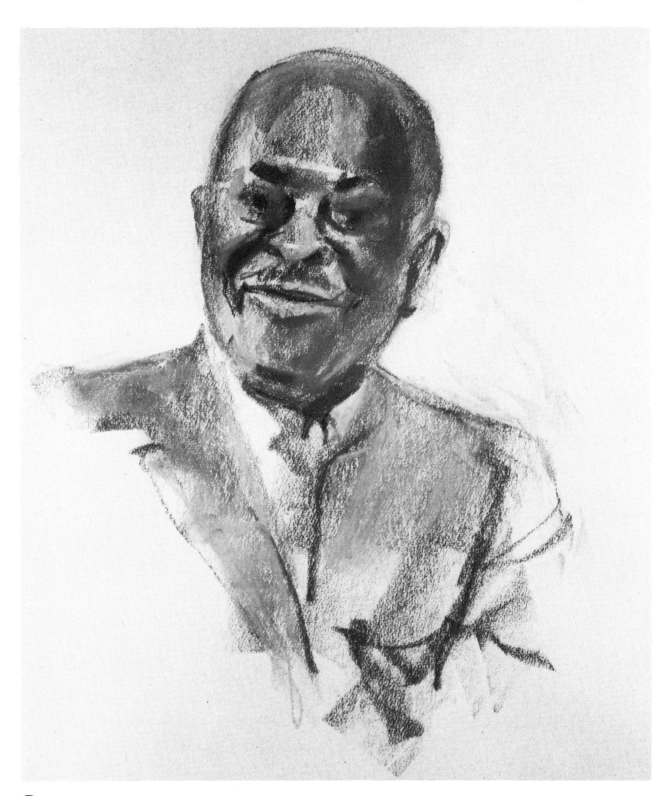

3. Now I use various grays to fill in the tones. First, I use a No. 4 gray around the top of the head, blending it with the darker No. 6 gray shadow alongside the forehead and into the eye. Still using a No. 6, I indicate his right eye and develop the lid areas. I angle the upsweeping eyebrows with the two wide strokes and add some quick calligraphic lines to the clothing. Then I switch to a No. 3 gray and brush the chalk over these lines.

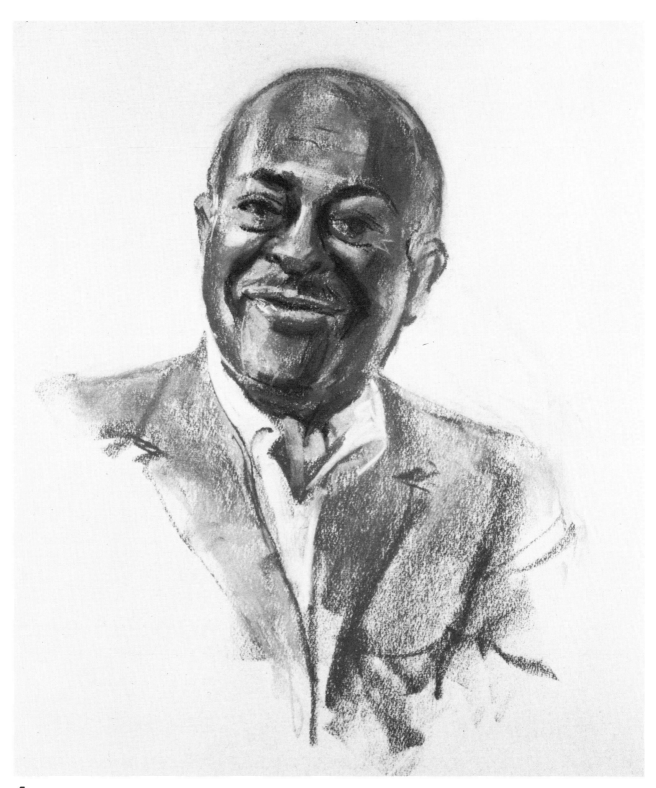

4. Here I begin again at the top of the head, adding more No. 3 chalk to its periphery to shape it better and to draw in some hair around the ears. With the pointed corners of a hard chalk, I bring the drawing into focus by carefully delineating the eyes, eyelids, nostrils, mouth, and chin.

I see that I'm losing the effect of the light shining from the left, so I choose a soft, round No. 2 and No. 3 chalk and work over the left side of the face. (Notice the lights on the temple, across the brow, on the cheek, and along the edge of the nose.) I also use the No. 3 chalk for highlights along the upper lip, on the left above the mustache, and between the mouth and chin. To develop the counterpart of that light plane, I use a No. 7 chalk for the shadow plane on the right side of the chin. I add the collar of his sport shirt with a white chalk.

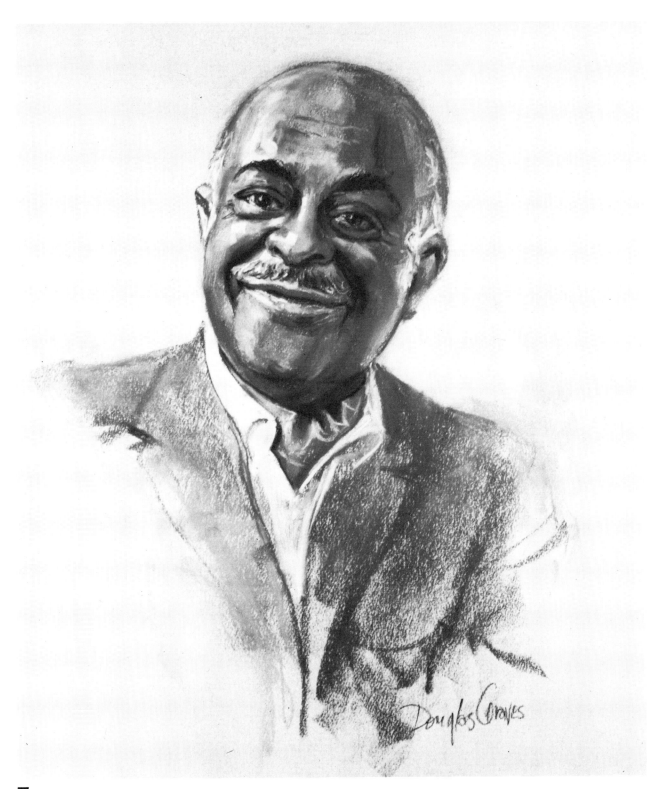

5. In addition to finishing the details of all the features, I stroke in broad areas of skin highlights. His lustrous skin lends itself to a portrait with lots of "sock." The darkest places are the depressions around the mouth and the deep nooks between the bridge of the nose and the eyes. (Note that using too much black on the edge of the side of the face that's in shadow would destroy the impact of these dark areas.) I add highlights in the eyes and the gray hairs in the mustache and sideburns last. I find the secondary light on the left side of the face a little disturbing, but perhaps it makes the portrait more dramatic.

23.
Mother and Children in Conté

Once you can draw a head pretty well, you might think that you've got the portrait business licked. But if you get a commission for a portrait with more than one figure in it, a whole group of new problems will arise. Naturally, the problems will be in direct proportion to the number of people in the portrait.

The average portrait usually consists of just head and shoulders. If you have two subjects alike in size, you might think that all you can do is put them side by side. Since that makes an uninteresting composition, a better idea would be to do each head in a vignette manner. Then you can put them anywhere on the paper in relation to each other. There are other possibilities, too. For instance, you could include more than just the head and shoulders, and seat them in some nice arrangement together (although they might fight like cats and dogs!): you might have one person seated and one standing. A parent and a child can be composed easily, as the child may snuggle up to the mother.

There are three people in this portrait—Mrs. Knoblock, and her children Gretchen and Eric. As I said in Chapter 5, three people are the easiest to arrange. It's a good idea to bring the subjects close together, even overlapping them. Such closeness is quite natural here, since the mother could draw her children comfortably close to her. For a contrast in the positions of the children, one could sit on her knee and the other snuggle close in by her side.

The position of Eric's head forms an interestingly off-center triangle with the other two heads. His dark hair and suit are visually weighty and if he were positioned any farther over to the left, this would throw the picture off-balance. The relative positions, weight, and depth of your sitters have to be considered carefully. Remember that here are three heads of different sizes. Although the children's heads aren't too much different from each other, Gretchen's should be a little daintier than Eric's. Mrs. Knoblock's head is farthest back, Gretchen's is slightly ahead of her, while Eric's is out in front somewhat. Therefore, due to his position, his head should be larger relative to the others—but if it's drawn too large, it won't look childlike.

After working out these nitty-gritty problems, the drawing should be easy—look at my beautiful subjects! Who wouldn't approach a project like this with zest! For this portrait I use a sanguine Conté crayon on a 25″ x 21″ Masonite panel, coated lightly with acrylic gesso. Before I began this drawing, I did a preliminary sketch in charcoal, to work out all those posing and size difficulties.

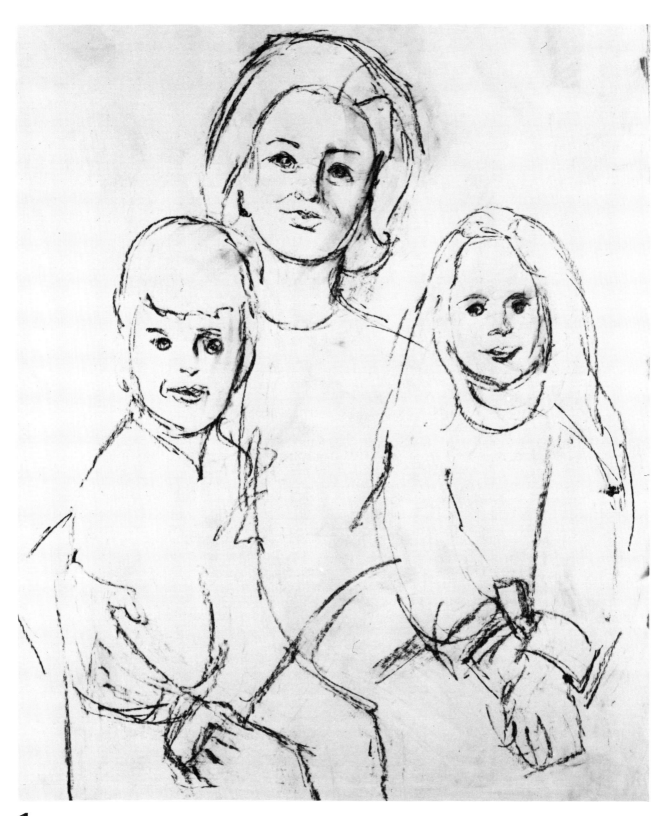

1. In this preliminary sketch, I compose the three figures, arranging the heads in a kind of isosceles triangle. Notice Eric's position, closer to the center of the portrait; this is to balance his greater visual weight.

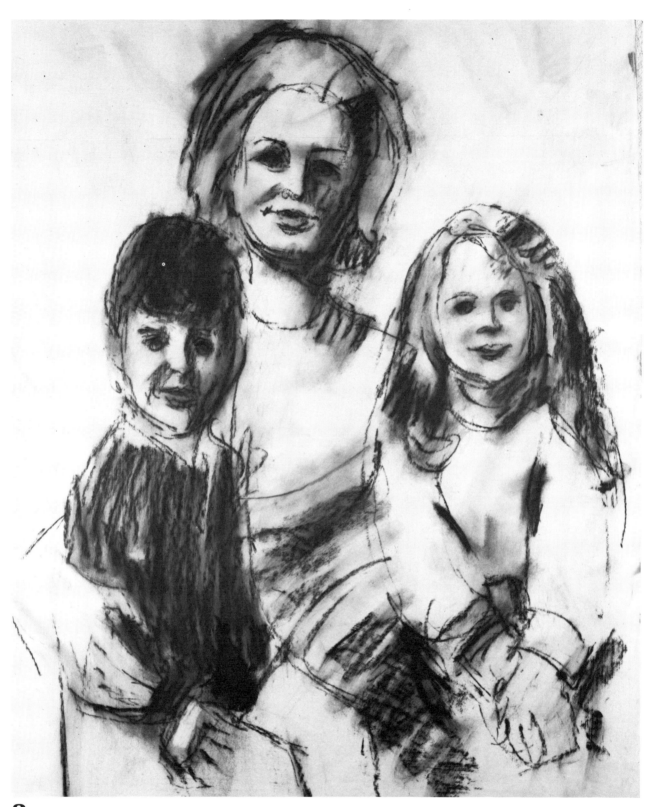

2. Now I begin to work some tone values in. I stroke in heavy amounts of Conté and then smear it around with pieces of paper towels or my fingers. It doesn't seem to disturb the line drawing so you needn't feel nervous about rubbing over the edges.

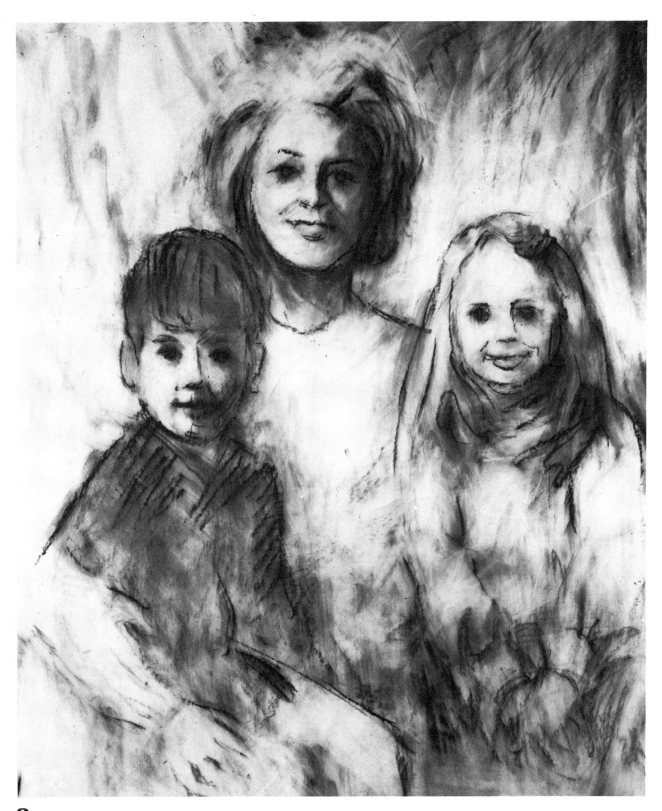

3. Now I start the lifting out process with erasers. This is to establish the lightest values—especially around Mrs. Knoblock's hair. Notice that I put in a shaded background as a foil for the blond hair. I work rather indirectly, rubbing tones in and then erasing them out a little. I like to continually change my mind about the tonal patterns. Here I erase quite a bit of the shading of the mother's dress, and wipe off a good deal of Eric's tone, because I wanted to redraw most of the figure.

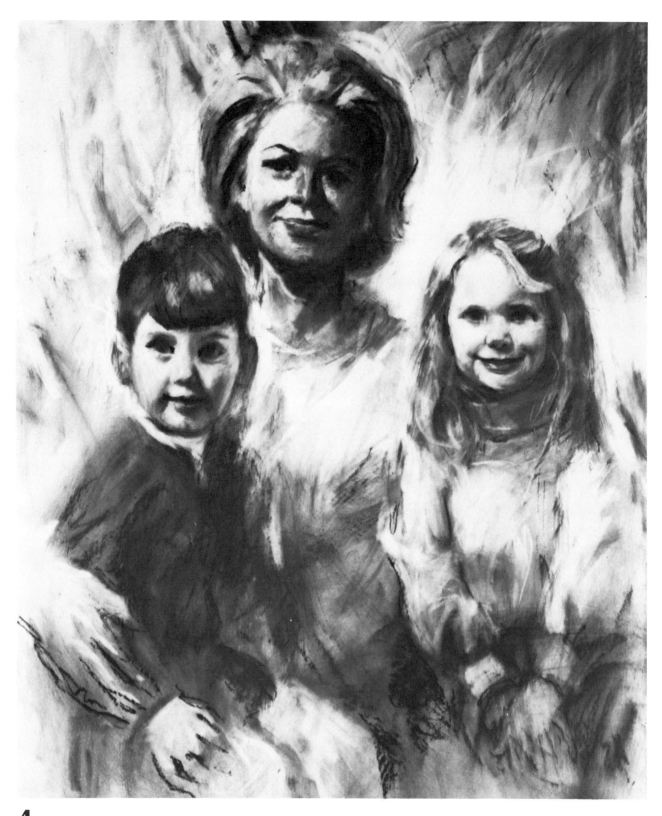

4. I start to develop the subtleties of the faces now—the roundness and the shadow patterns. First, I smear the shading with my finger and then use either a kneaded eraser to take off delicate shadings, or the pointed ink eraser to erase down to the board, in such places as on the children's noses, lower eyelids, and around their mouths. I use the ink eraser to cut out strands of hair on Gretchen. I remove the larger strokes on Mrs. Knoblock's blouse and in the background with a Pink Pearl eraser.

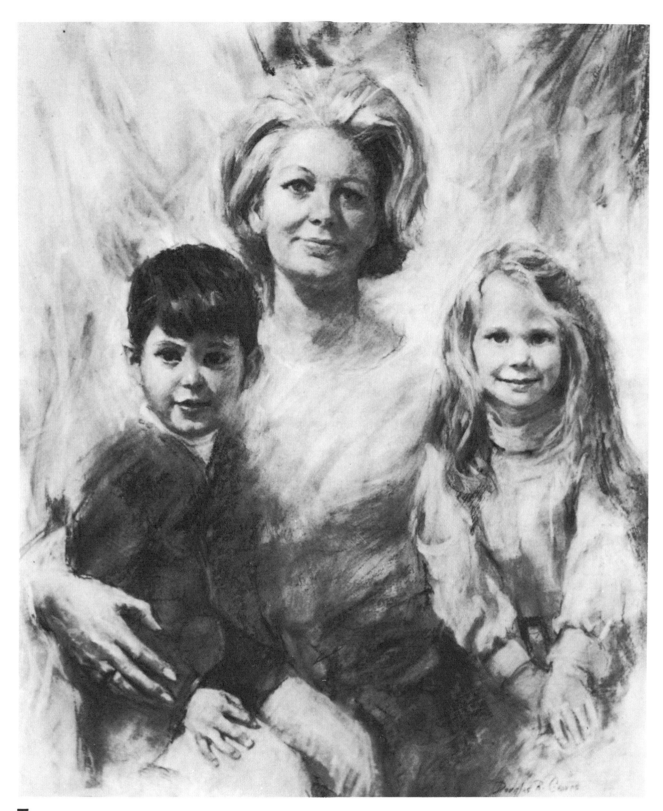

5. I do a considerable amount of work in this step. I bring tone values in the faces closer together by lightening the shadows and muting the lights with a velvety layer of tone. I fuse the tones around the eyes and mouths. I also deliberately fuse lots of edges, such as Eric's left cheek, Mrs. Knoblock's shoulder, and Gretchen's hair where it frames her face. Notice that I focused attention on the faces and hands while the garments are only roughly indicated, as compositional devices. Finally, I decide to add some heavy raw strokes to pep up the drawing and keep it from looking too vapid.

24.
Family Group in Conté

I don't remember if I was nervous when I first got the commission for this portrait of the Jacobs family, but I should have been. Here I have five people to arrange in one drawing, four of them children, all restless and energetic as the young usually are. Getting all these people to stay posed for such a delicately balanced composition should be enough to drive any portraitist to paint flowers! The problems of achieving a likeness in a portrait such as this are multiplied fivefold—especially when the rest of the family and their friends are also going to see and judge it. Everyone will have his own opinion about whether each likeness is true or not.

Again, as in the previous group portrait, the question of relative proportions arises. Are the children in front—Cheryl, Chris, and Mary Beth—the correct size relative to the others, without making them look older or younger? A child may be large for his age but

if I show it, he may appear too old. Also, each child stands at a varying distance from the viewer, so in perspective the nearest ones should be larger. Will that make the child unusually large for his age?

You can't use a photograph for any basis of measurement because of lens distortion. The answer is to judge these relationships from life, that is, by having the sitters pose in correct positions and measure by comparison. In a portrait with several figures, after the initial block-in (with all present), you should then call each person to sit separately. It would be almost impossible to work on a group portrait with everyone on deck at each sitting. I don't know who would suffer more, the sitters or the artist.

This is a 30″ x 32″ drawing on Masonite covered with two thin coats of acrylic gesso. The technique is the same as in the Knoblocks' portrait in the preceding project.

1. I sketch in the figures from snapshots I took of various arrangements of the subjects. With a busy family of this size, that is the most expedient way to start. Don't let it offend your esthetic dedication to art. Believe me, if the early masters had had a camera, they probably would have used it—some of the later ones did.

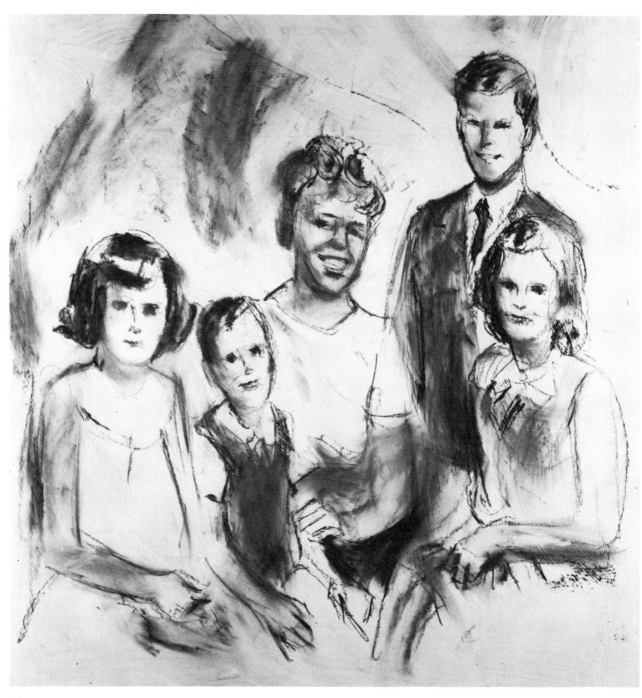

2. Here I lay in some of the tonal masses; these are mostly the darkest spots on the hair and the clothing. I very roughly daub in the features—the eyes, the noses, and the hands, With a paper towel I rub in some of the lighter values.

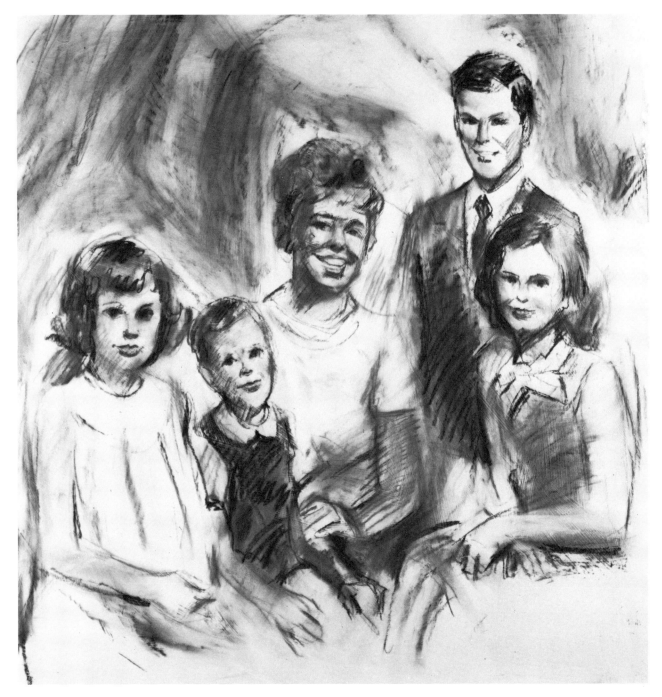

3. Here I add still more Conté material, blending to bring out facial forms and features and striving for likenesses. I note the slight differences between the subjects, not only in skull structure but expressions and gestures—like the tilt of heads.

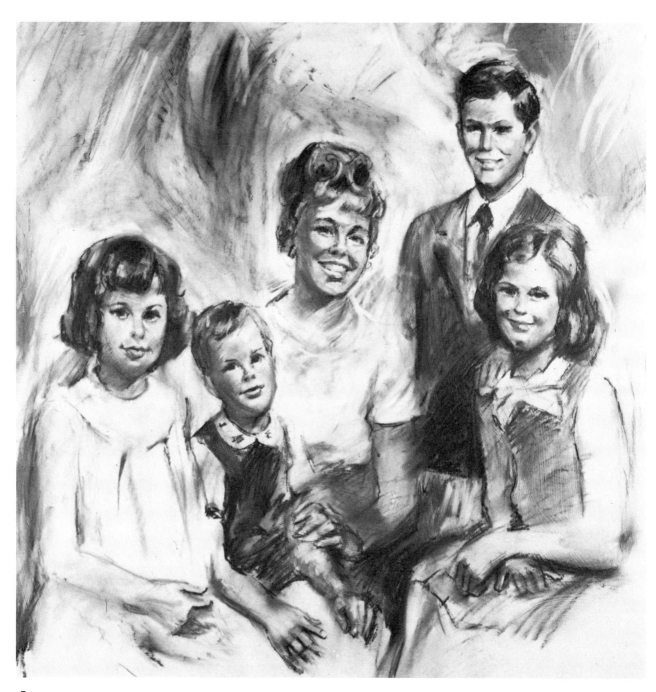

4. I close in on my targets in this step by adding more light tones to the facial forms. I've tried in these demonstration steps to develop all the figures along together, however, in actual practice, I might finish one subject completely while the others were several stages behind. I start to lift out highlights with erasers. Notice Mrs. Jacobs' face. In Step 3 I had rubbed a tone over most of it; now I re-establish the highlighted forms by erasing in the hair, on the forehead, along the upper lip, and on the nose, teeth, lower lip, chin, and blouse. This gives a painterly appearance to the drawing, which I especially like.

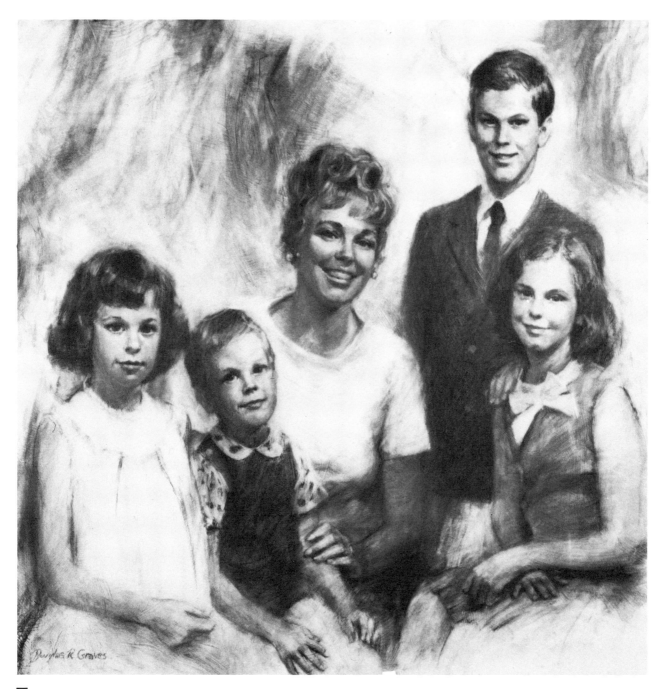

5. Here I soften and smooth all the tones and edges in the portrait, making sure that all of the important features upon which the individual likeness is based, are firmly defined. You can probably find a slight family resemblance around the eyes; however, notice also the dissimilarity in cornea size, and in the facial planes surrounding them. The lips also have a same basic shape; their individual character depends on the action of the muscles around the mouth.

Vernon Stake. *15″ x 19″. Fifteen-minute charcoal sketch. Collection of Frances Schramm.*

Conclusion

Getting a likeness is the one thing that a portrait artist searches for above all else. My students always want the secret capsulated for them in one key sentence. The experienced portraitist realizes (through trial and error) that getting a likeness is a dynamic and evolutionary process, based on *observation*.

You start by observing the basic surface shapes—the eyes, nose, and mouth—noting how these vary subtly from the ideal symmetrical forms. (Such observation is aided by your knowledge of human anatomy.) You learn to see your sitter's personality manifested in his gestures, attitudes, and posture. You might even unconsciously capture some very deeply hidden emotion. This happened to me once, when I caught a sadness in my sitter that stemmed from a fatal illness. (Of course, this kind of insight is usually beyond the control of the artist.)

The business end of portraiture should be conducted as with any profitable enterprise—in a sensible, straightforward manner. Your client is buying a hand-crafted product to order, and the one thing you have to supply is a satisfactory likeness. What style you do it in is up to you. Make sure they understand that.

If more than one person views your work in progress, you'll get all kinds of suggestions (many contradictory). You either have to listen patiently and do it your own way, or limit the kibitzers to just the person who commissioned you. Try to avoid doing a portrait as a surprise unless you're working from a photograph that's already in favor with your client.

My best wishes go with you in your career!

Bibliography

Cheek, Carl. *Drawing Hands*. New York: Grosset and Dunlap, Inc., and London: Pitman Publishing, 1959.

Hale, Robert Beverly. *Drawing Lessons from the Great Masters*. New York: Watson-Guptill Publications, 1964.

Hogarth, Burne. *Drawing the Human Head*. New York: Watson-Guptill Publications, 1965.

Hogarth, Paul. *Creative Ink Drawing*. New York: Watson-Guptill Publications, 1968.

———. *Creative Pencil Drawing*. New York: Watson-Guptill Publications, 1964.

———. *Drawing People*. New York: Watson-Guptill Publications, 1971.

Laliberte, Norman, and Alex Mogelon. *Drawing with Pastel, Charcoal, and Chalk*. New York: Van Nostrand Reinhold Co., 1973.

———. *Drawing with Pencils: History and Modern Techniques*. New York: Van Nostrand Reinhold Co., 1969.

Loomis, Andrew. *Drawing the Head and Hands*. New York: Viking Press, Inc., 1956.

Norton, John. *Painting and Drawing Children*. New York: Watson-Guptill Publications, and London: Pitman Publishing, 1974.

Ormond, Richard. *Sargent: Paintings, Drawings, Watercolors*. New York: Harper & Row, Publishers, 1970.

Perard, Victor. *Drawing Faces and Expressions*. New York: Grossett and Dunlap, Inc., and London: Pitman Publishing, 1958.

Pitz, Henry C. *Charcoal Drawing*. New York: Watson-Guptill Publications, 1965.

Richer, Dr. Paul. *Artistic Anatomy*. Trans. and ed. by Robert Beverly Hale. New York: Watson-Guptill Publications, 1971. London: Pitman Publishing, 1973.

Index